WALTRAUD NAWRATIL

ABSTRACT ACRYLICS

NEW APPROACHES TO PAINTING NATURE USING ACRYLICS WITH MIXED MEDIA

SEARCH PRESS

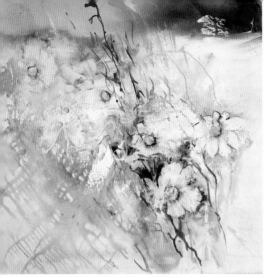

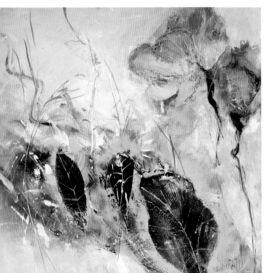

BEFORE YOU BEGIN

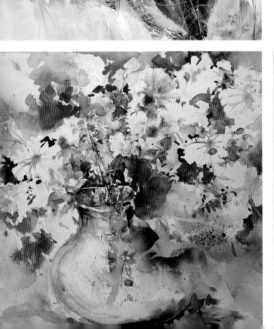

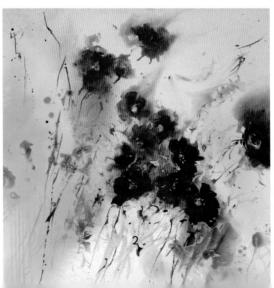

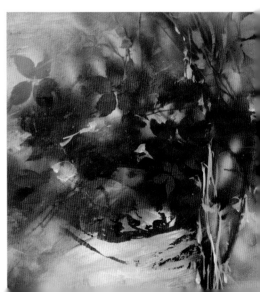

PROJECTS

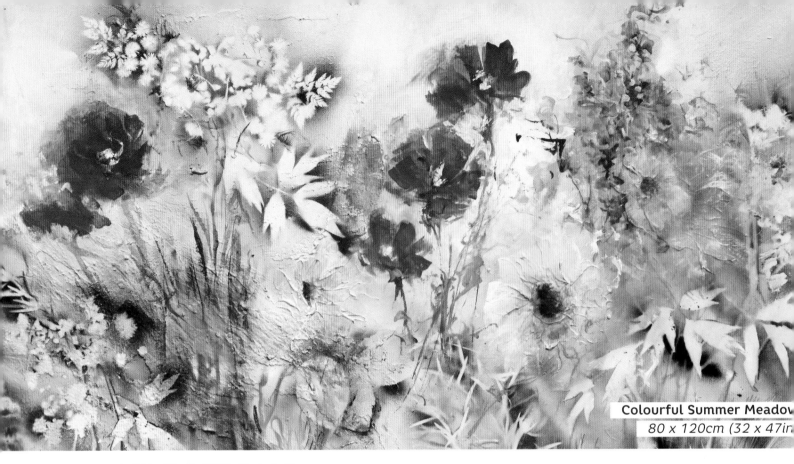

REFLECTIONS

This book has two purposes. First, it is my attempt to guide your eye and your perception to the lavish yet soothing colours found abundantly in nature, and to capture the particular magic of these colours that we feel when we see them. Colour both enthrals us and gives wings to our imagination. The second purpose is to draw your attention to the variety of techniques used in acrylic painting that you can then apply in your artwork to reproduce all the colours that you see in nature.

The secret to painting successfully is not to get lost in routine. Try to stop your paintings from becoming too similar, even if that means choosing different subjects that you would not have attempted before.

Within these pages, I would like to encourage and help you as you try new ideas and new working methods in your paintings. I am sure you are already familiar with at least some of the techniques I will be talking about, but perhaps I will still be able to surprise you with a new method, or a combination of techniques.

I hope that you see this book more as a source of inspiration, rather than a list of instructions. Don't just copy my suggestions, but let my pictures inspire you in your own, new creations. Inspiration doesn't have to end with a particular version, but should be used in lots of different ways.

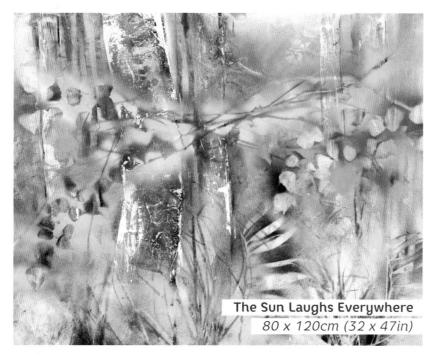

The Sun Laughs Everywhere
80 x 120cm (32 x 47in)

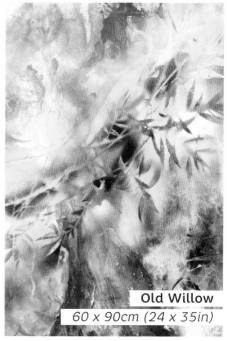

Old Willow
60 x 90cm (24 x 35in)

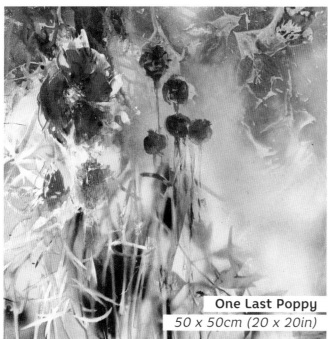

One Last Poppy
50 x 50cm (20 x 20in)

Nature is constantly changing, and with it you can keep developing your painting style. Use this book to explore the many options that acrylic painting in mixed media offers.

TOOLS AND MATERIALS

In this chapter I am going to be telling you about the materials and tools I use. Some will be new to you; others you may have already used yourself.

PAINTING SURFACES

The easiest surface is to work on is a canvas-covered stretcher frame. They are available from a wide variety of craft shops in lots of different sizes and thicknesses. I suggest you choose one with a frame thickness of at least 2cm (¾in), as the wooden frame can easily distort if it gets too wet. This can also happen if you apply modelling paste to large areas and the canvas gets very heavy.

If you use watercolour paper, particularly for the projects later on that have a watercolour style (see pages 98–109), then I suggest you choose paper with a minimum thickness of 600gsm (300lbs), as lighter paper will get too wrinkled and distort. You will also need a separate stretcher frame for this.

Watercolour paper

Canvas-covered stretcher frame

Plastic bowls for diluting acrylic paint

Roll of canvas as an alternative palette

Small plastic bottles for diluting and applying acrylic paint

Spray bottle for water

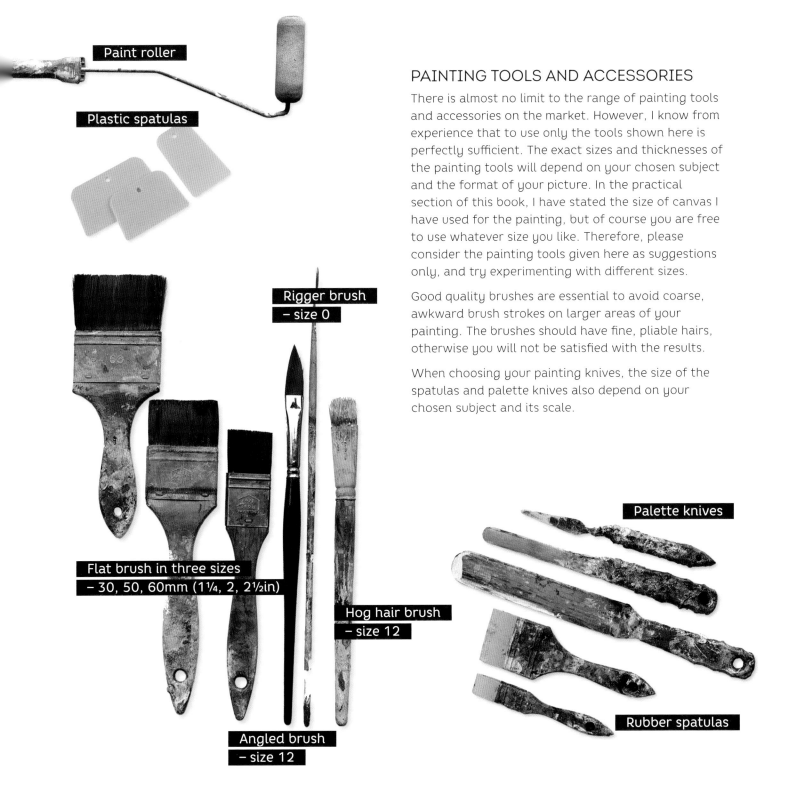

Paint roller

Plastic spatulas

Rigger brush
– size 0

Flat brush in three sizes
– 30, 50, 60mm (1¼, 2, 2½in)

Hog hair brush
– size 12

Angled brush
– size 12

Palette knives

Rubber spatulas

PAINTING TOOLS AND ACCESSORIES

There is almost no limit to the range of painting tools and accessories on the market. However, I know from experience that to use only the tools shown here is perfectly sufficient. The exact sizes and thicknesses of the painting tools will depend on your chosen subject and the format of your picture. In the practical section of this book, I have stated the size of canvas I have used for the painting, but of course you are free to use whatever size you like. Therefore, please consider the painting tools given here as suggestions only, and try experimenting with different sizes.

Good quality brushes are essential to avoid coarse, awkward brush strokes on larger areas of your painting. The brushes should have fine, pliable hairs, otherwise you will not be satisfied with the results.

When choosing your painting knives, the size of the spatulas and palette knives also depend on your chosen subject and its scale.

PAINTS

For the basic colours, I use acrylic paints by Daler Rowney, and for more special shades and airbrush paints I like to use Schmincke products. For fluid acrylics I use Aquacryl™, available via Lascaux Colours & Restauro. The acrylic paint sprays I use come from various manufacturers.

Acrylic paints

Acrylic paints are available in different price ranges. I suggest you obtain your products from an art supplier: cheaper products don't have the same amount of colour pigment as higher-quality paints, which will stop you from achieving the desired shades and brilliance you would like for your picture. Besides regular acrylic paints, I also like to use heavy body acrylics. This type of paint is very soft and thick, and produces an effective, textured surface when applied using the painting knife technique. It is particularly suitable for creating flowers.

Fluid acrylics

These paints are used like acrylic paints, but are transparent and as light as watercolours. The colours remain intense in shade, even when generously diluted with water. Take care not to work with too much moisture, both when overpainting with acrylic paints and when setting, so the colours do not mix unintentionally and the fluid paint dissolves.

Acrylic paint spray

In this book, I have complemented my 'usual' paint palette with a new addition: acrylic paint sprays. Used in tandem with natural materials, you can achieve endless possibilities with these sprays, as you will soon see in the following paintings. As there is such an extensive range of colours in these paints, it will take some time to find the optimum shades for you. I suggest you use water-based paint sprays when you start, as they don't smell so strong and there is less mist. In addition, unlike solvent-based spray paints – which are repelled by acrylic paints, water-based paint sprays mix with acrylics. Although you can achieve wonderful textures by combining solvent-based spray paints with acrylics, it is not suitable for my work.

Different spray cans also have different nozzles. If you use a nozzle with a thin line, you will find it easier to control the spray.

I also suggest cleaning your spray heads with a cleaning spray after use; otherwise, they soon become sticky.

I recommend you wear a face mask when using paint sprays, and possibly even protective eyewear.

Airbrush paints

Airbrush paints are very bright liquid paints with an acrylic base, originally developed for use with spray guns but can also be applied by brush. If you spray a little water over the airbrush paints, they will run into the picture with the same vigour as fluid acrylic paints. You won't achieve results like this with any other painting method.

Acrylic paints

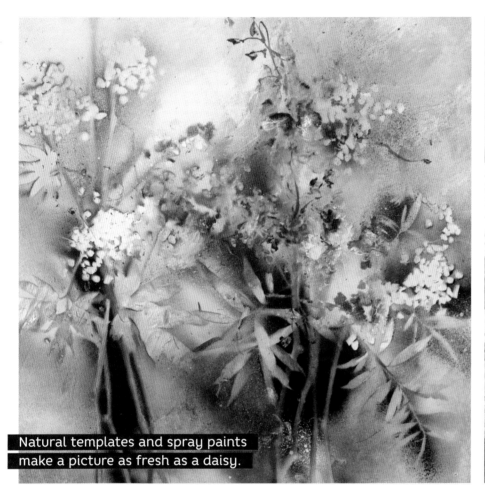

Natural templates and spray paints make a picture as fresh as a daisy.

Fluid acrylics

Acrylic spray paint

Airbrush paints

ADDITIONAL MATERIALS

Clear plastic wrap (cellophane)

For this technique, I tend to use the protective film that comes with my canvasses. This is a quick and easy way to create an interesting, textured background, although you will need to paint over parts of it. It is easy to reproduce grasses and leaf textures, imprints of ferns and much more by placing the film on the painted picture while it is still wet.

Gesso

This is diluted with water and then used to prime the canvas. Colours adhere to it beautifully. It provides good coverage and a smooth, even surface for painting on.

Modelling paste, fine or coarse

Excellent for adding further interest to your paintings. Ready-to-use products are available from art suppliers. However, you can also mix your own modelling paste in your preferred consistency from sand, marble powder, acrylic binder and acrylic paint either directly on the canvas, or on a separate plastic mixing plate or bowl.

Transfer glue

I like to use Hobby Line's Foto Transfer Potch. This is a special transparent, water-based paste that is used for adhering laser-printed photos or fonts on to various surfaces.

Modelling paste

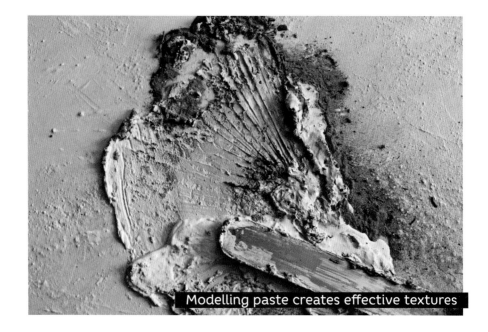
Modelling paste creates effective textures

TEMPLATES FOUND IN NATURE

Craft shops sell all sorts of templates. However, in this book I'd like to tell you about slightly different templates that you can find for free – natural ones growing in woods or forests, fields or meadows, and even your own garden.

Use the variety and abundance that nature provides, and collect leaves, grasses, ferns and stalks! Remember that these natural materials won't last very long, even if you press and dry them. However, there is a way of preserving them for a little longer. You can purchase 'sealing' or 'preserving' sprays from florists or online; this covers the plants in a protective film. To preserve special seasonal leaves, such as Japanese Maple or similar which you can find only until around the end of autumn, press them slightly and then spray well on both sides. The leaves will stay soft so you can use them time and again.

Press leaves, stalks or ferns flat briefly before you spray them. You can use a rolling pin or a spray can to do this. A tree trunk created with modelling paste, painted in strong autumn colours and with leaves sprayed with acrylic spray printed over the top, will result in a realistic tree.

Leaves, grasses and stems

Japanese Maple

Ferns

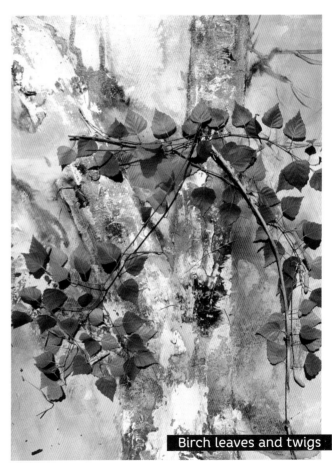

Birch leaves and twigs

SOURCES OF INSPIRATION

IDEAS

I find it almost impossible to walk past a brightly coloured, uplifting image – be it a work of art, a field of yellow, meadows full of flowers or rainbow-hued gardens – without experiencing some emotion. Colours affect our senses too much to ignore. Certain colours or colour variants have even become symbolic, recognized for representing qualities and basic human emotions and qualities, such as green representing hope.

I also associate colours with the constantly changing seasons. The whites, yellows, soft lilacs and pinks of snowdrops, black hellebores, narcissi and primroses are the lightest shades in nature's colour chart, and are the first colours to return to the scene in late winter and early spring. The translucent blue of the spring sky, and the first tender green buds bursting forth unstoppably amongst the decaying remains of the previous year's growth follow on. If we haven't already done so, this is the time of year when we realize that there are a thousand-and-one blues and, likewise, countless shades and tones of red and green.

Simple loveliness, blossoming wilderness, masses of flowers on the banks of a lake... Despite the numerous photos that I have taken over the years I have been painting (as you will see on pages 14–27), I still always go out with my eyes wide open to colours of nature and its various hues, constantly looking out for beauty to get ideas for new pictures. You needn't look far for inspiration: a garden with unspoilt green spaces, where cultivated plants and wild flowers live happily side by side, is just as inspiring as a field of wild flowers in the countryside in late spring, when the last buds have opened and waves of stalks sway gently and freely in the breeze.

Flowers and leaves, trees and landscapes constantly appear in a new light over the course of the year. Subjects, such as sunlight on early summer trees, light birch trees beside a sunny stream and fiery maple and beech trees in autumn, create an impression of fairytale forests and avenues of light over the changing of the seasons. The change in seasons also offers artists endless opportunities for collecting items for our paintings. In particular, don't miss the colours of foliage in autumn, with their relentless urge to wilt and fall from the trees. Invest in time and relaxation, sitting on a wooden bench in an autumn forest, to store this autumn sight in your mind's eye, and then incorporate it in your own artwork along with all the natural materials you have collected, such as leaves and bark.

Seize the opportunity to be inspired by nature's treasures. You'll soon see that the ideas just keep on coming!

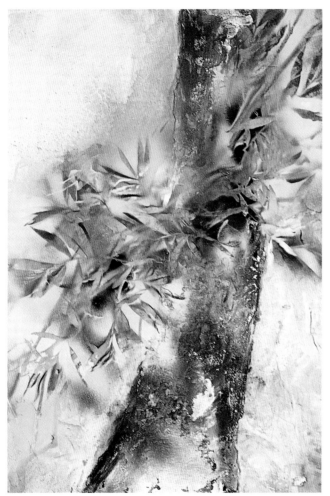

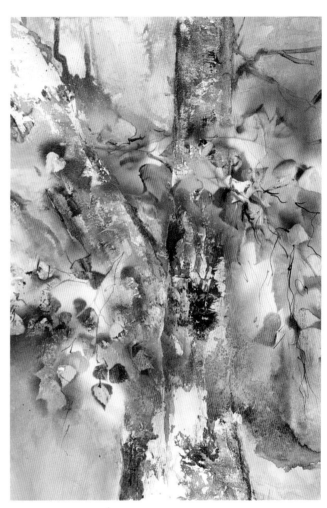

Spring
60 x 90cm (24 x 35in)

Autumn
60 x 90cm (24 x 35in)

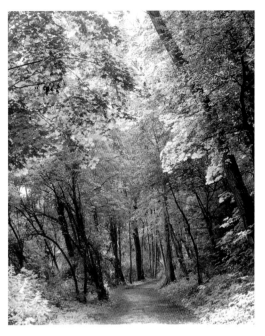
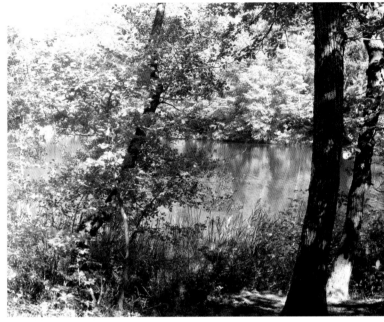
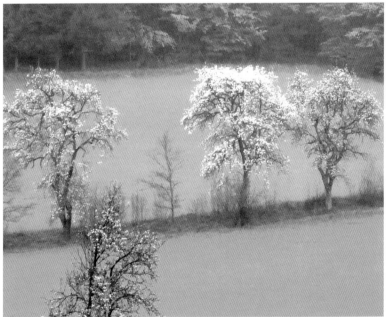
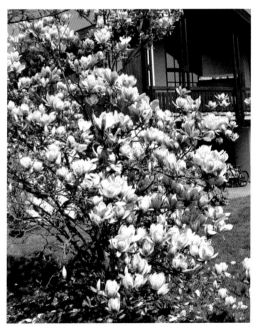

FROM A PHOTO TO A PAINTING

In this chapter, I'll be giving you a brief insight into a selection of the photos that inspired me when painting the various pictures.

Some of these paintings are absolutely true to nature, but most are modified and sometimes very loosely based on the original, inspired only by the colours. Even the gloomy autumn forest still produces a bright display of colours, and it is fascinating to study the construction of the deciduous trees. It's easier to see the differences in the varieties of plants and trees in autumn, compared with summer.

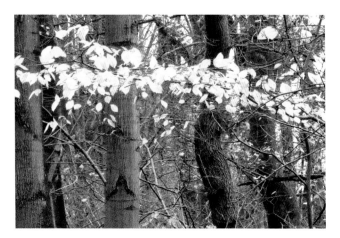

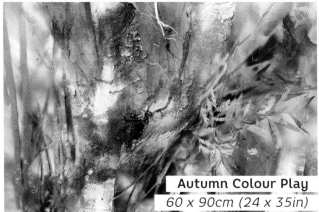

Autumn Colour Play
60 x 90cm (24 x 35in)

Chestnut tree

The chestnut tree in our garden is always happy to model for me. Its spring leaves are still perfect in early summer. Once the sun is burning in the sky, their fresh appearance gradually disappears.

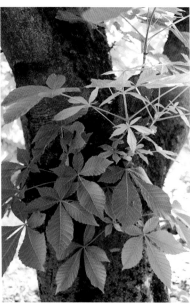

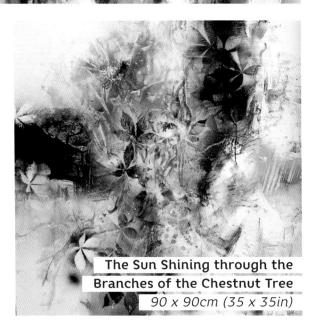

The Sun Shining through the Branches of the Chestnut Tree
90 x 90cm (35 x 35in)

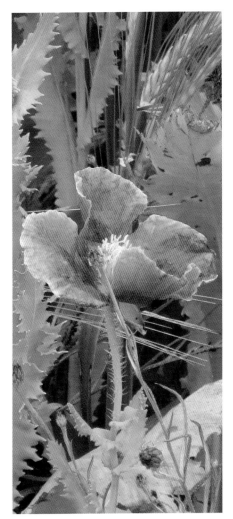

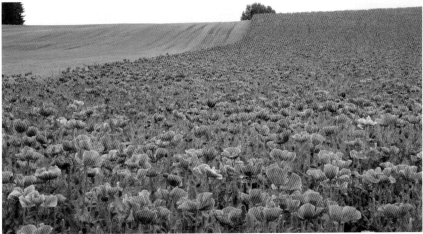

Pink Flower, no. 1
15 x 20cm (6 x 8in)

Pink Flower, no. 2
15 x 20cm (6 x 8in)

Summer is here

It doesn't have to be a perfect reproduction of a photo; the sight of this fairytale poppy field is sufficient inspiration for soft pink pictures of flowers. Summer truly arrives in these colourful weeks when these flowers finally bloom.

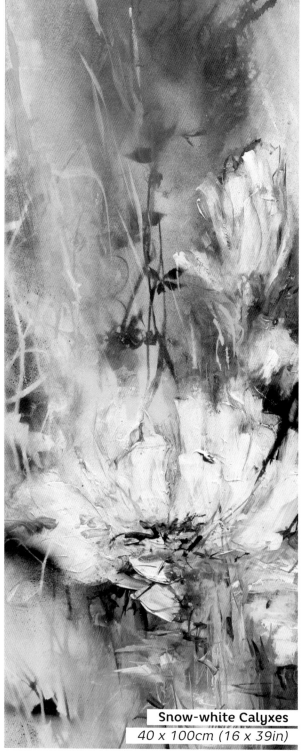

Hellebores in the park

While it is exciting to travel to new places to seek out new colours and forms, you don't have to go to far-off countries to find inspiration. A walk around your local area will often reveal little surprises like this park with a pond of water lilies. Don't forget your camera!

Snow-white Calyxes
40 x 100cm (16 x 39in)

Strong natural colours

A weed in any well-tended flowerbed can provide as much colourful inspiration as a rampant evening primrose. A snapshot in the early morning, before the primrose closes its bright yellow calyxes...

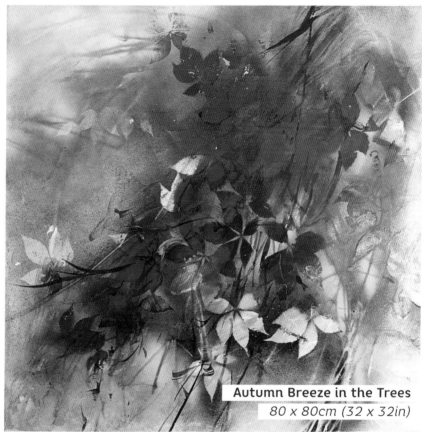

Autumn Breeze in the Trees
80 x 80cm (32 x 32in)

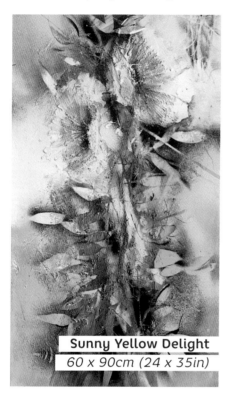

Sunny Yellow Delight
60 x 90cm (24 x 35in)

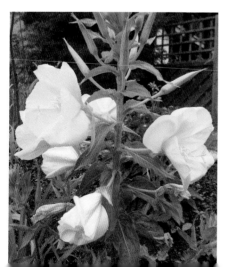

...or a few tendrils of Virginia creeper that cheekily wind themselves around the branches of the pine tree... It's autumn and the colours are getting brighter. Nature breathes deeply in the sunshine and warmth, and gives herself up to one last burst of colour.

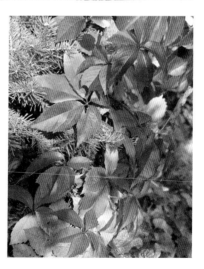

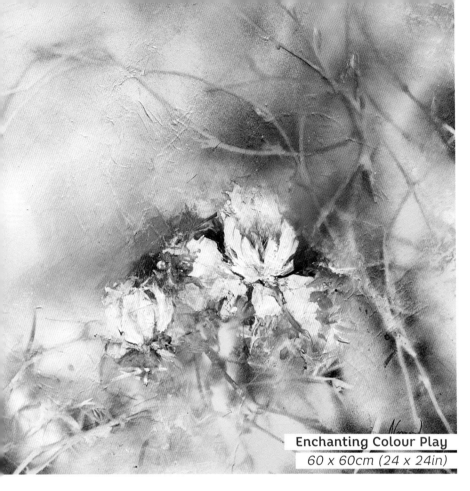

Enchanting Colour Play
60 x 60cm (24 x 24in)

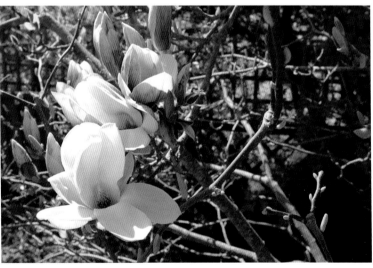

The magnolia

Every year I look forward to the almost recklessly early flowering of magnolia trees. Again, it is important to photograph sources of inspiration when you can: I photographed these huge, porcelain-like flowers on the leafless branches quickly, before they were taken by the last frost.

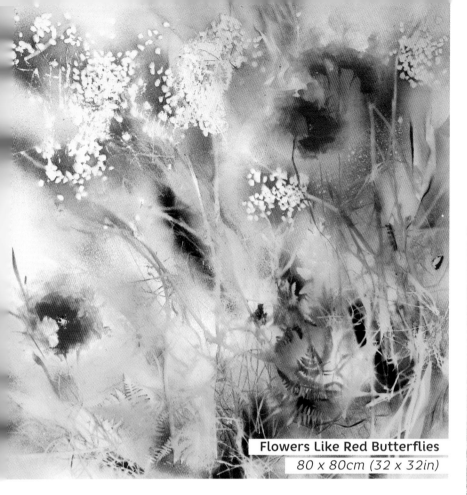

Flowers Like Red Butterflies
80 x 80cm (32 x 32in)

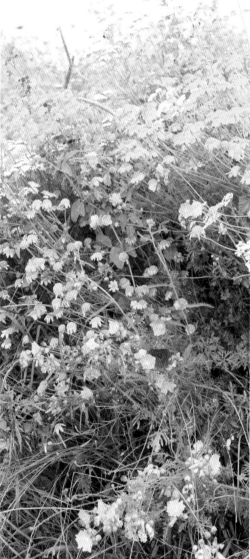

Summer meadow

An abundance of annual summer flowers, tall, waving grasses and tiny red dots amongst the golden meadow – this meadow was an enchanting subject.

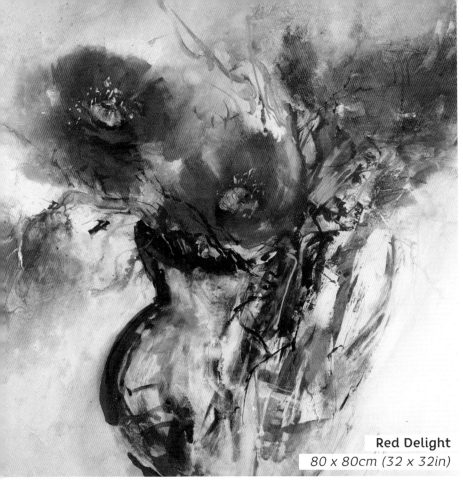

Red Delight
80 x 80cm (32 x 32in)

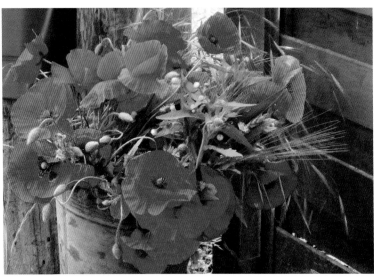

Red poppy

Poppy petals fly away like butterflies if you try to pick them, but if you take them as buds and arrange them in a vase, the flowers will open. A vase of bright, summery cheer and joie de vivre.

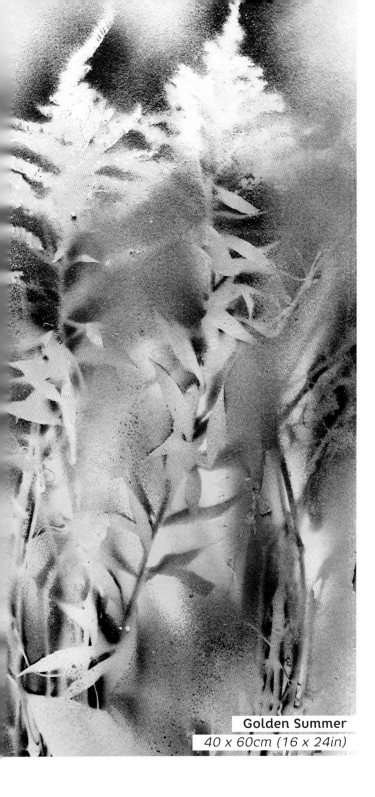

Golden Summer
40 x 60cm (16 x 24in)

Farewell to summer

The radiant, yellow goldenrod is at home everywhere more than any other flower, and to me it represents late summer in all its glory. But, by the same token, it also strikes the first notes of autumn.

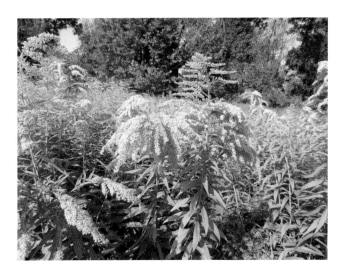

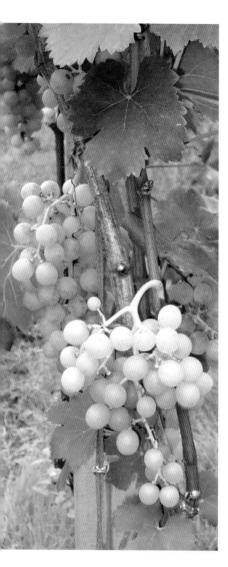

Vines

Sun-seeking grapes glow golden through the green leaves of the vines.

Sweet Grapes
15 x 20cm (6 x 8in)

Golden Fruits
15 x 20cm (6 x 8in)

Harvest of life

An ancient, gnarled vine. The grapes it bears are dark blue and wonderfully sweet.

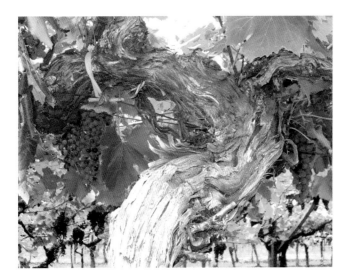

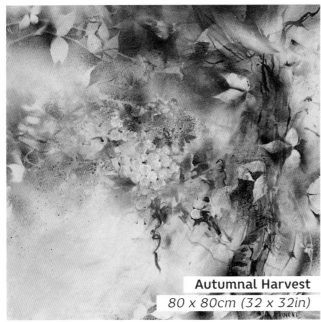

Autumnal Harvest
80 x 80cm (32 x 32in)

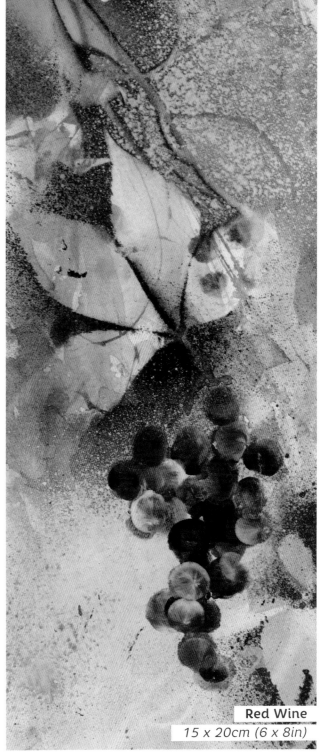

Red Wine
15 x 20cm (6 x 8in)

TECHNIQUES

After many years of painting only in watercolours, it was time for something new. Acrylic paints offered plenty of exciting options. Because of my lack of experience, initially I worked mainly using the watercolour technique (see pages 98–109) as watercolour was, after all, a familiar medium to me.

But time brought new sources of inspiration and alternative methods of painting. I went through phases of using each new painting technique with a passion, which I still do today: I would learn a new technique and paint with it in many different variations, almost endlessly. There then came a time when I realized that my paintings were starting to become too one-sided, and seemed to lack the qualities I wanted to create in my pictures. It was then that I began to combine multiple methods.

We artists are driven by the urge to keep blazing new trails, and respond to even the tiniest inspiration with the greatest enthusiasm.

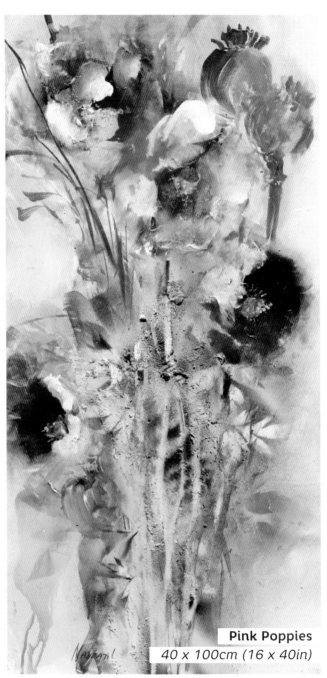

Pink Poppies
40 x 100cm (16 x 40in)

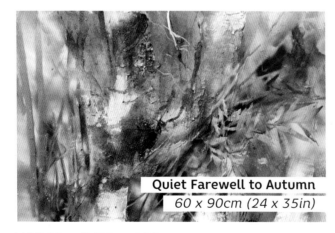

Quiet Farewell to Autumn
60 x 90cm (24 x 35in)

USING MIXED MEDIA

PAINTING KNIFE TECHNIQUE

Rosehips (Detail)
90 x 90cm (35x 35in)

SPRAY PAINT TECHNIQUE

Soft Fragrance of Spring
80 x 80cm (32 x 32in)

MAKING WATERCOLOUR

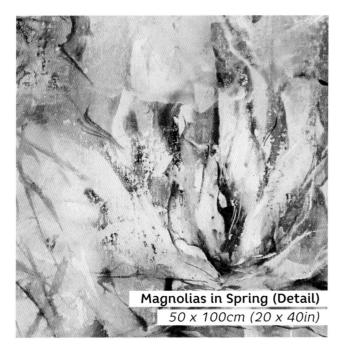

Magnolias in Spring (Detail)
50 x 100cm (20 x 40in)

TRANSFER TECHNIQUE

Gina
30 x 30cm (12 x 12in)

PHOTO TRANSFER

HOW TO USE THIS BOOK

'Mixed media' is a heading that could be applied to most of my paintings, because not only do I like to use different paint media at the same time, but I also like to combine a variety of techniques. For the purposes of this book, I have divided this heading into separate chapters that each focus on a particular technique. I have selected six special techniques for this book that I am going to tell you about.

The following pages contain detailed descriptions of these techniques. If the main part of the picture is worked with a spatula or palette knife, it will come under 'Painting knife technique'; the same applies to 'Spray paint technique' and so on.

You'll find the tried-and-tested methods such as watercolour and palette knife techniques here, as well as a few special ideas that I have rediscovered for myself, including working with clear plastic wrap (cellophane) and acrylic paint sprays.

Whichever technique you use, and however difficult it may be to experiment with at the beginning, the results are worth it! Remember, whether you choose to paint flowers, trees or a still life, it is important that you first spend time looking at your subject in depth in order to truly capture texture or form; be it the structure of the tree bark or the shape of the leaves.

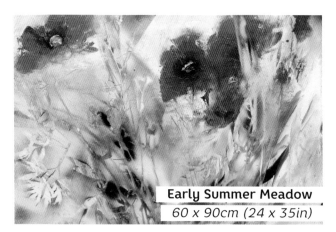

Early Summer Meadow
60 x 90cm (24 x 35in)

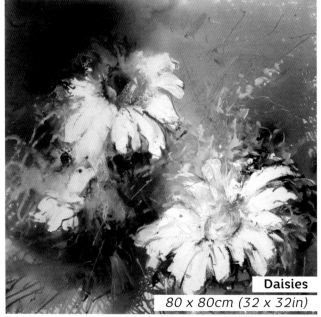

Daisies
80 x 80cm (32 x 32in)

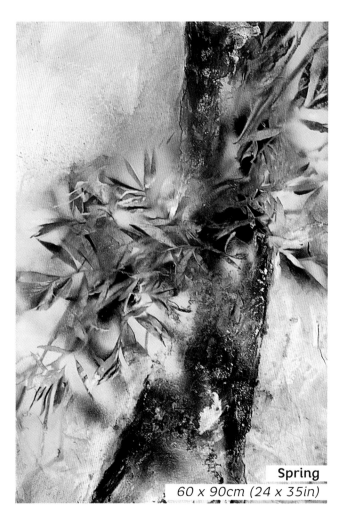

Spring
60 x 90cm (24 x 35in)

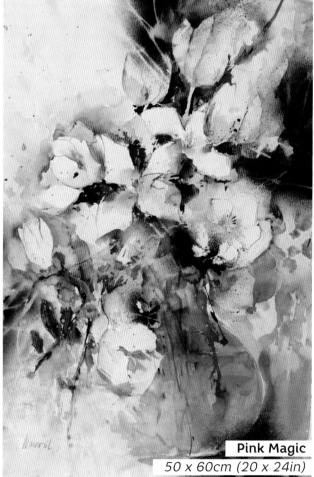

Pink Magic
50 x 60cm (20 x 24in)

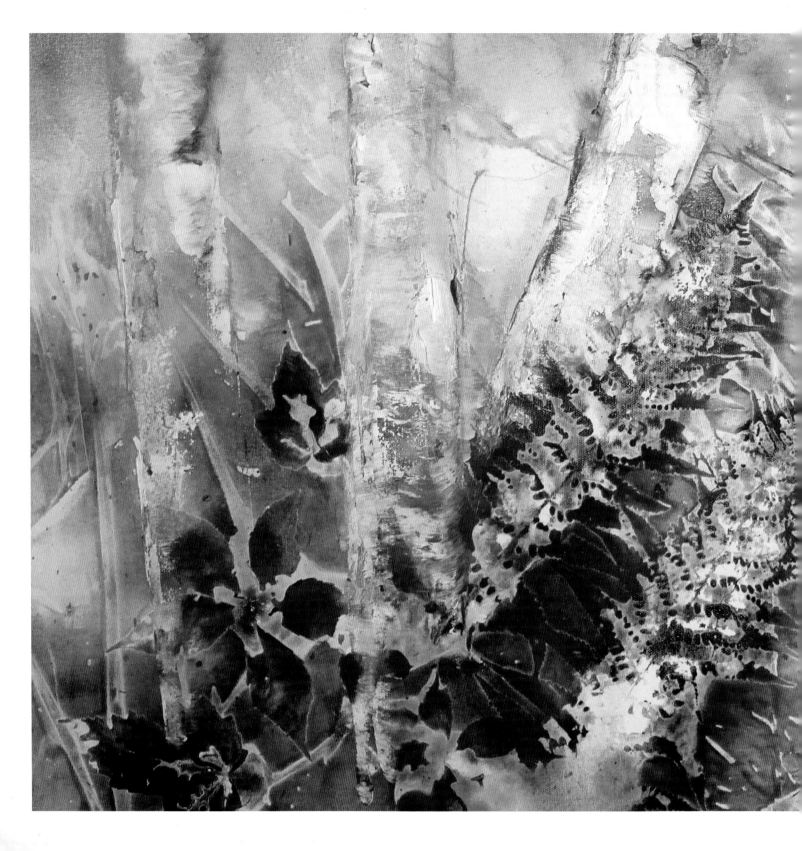

TRANSFER
TECHNIQUE

As well as using clear plastic wrap
(cellophane), adding leaves, grasses
and flowers to your painting can
create interesting effects and
introduce nature into a picture, so
that it is always close to you.

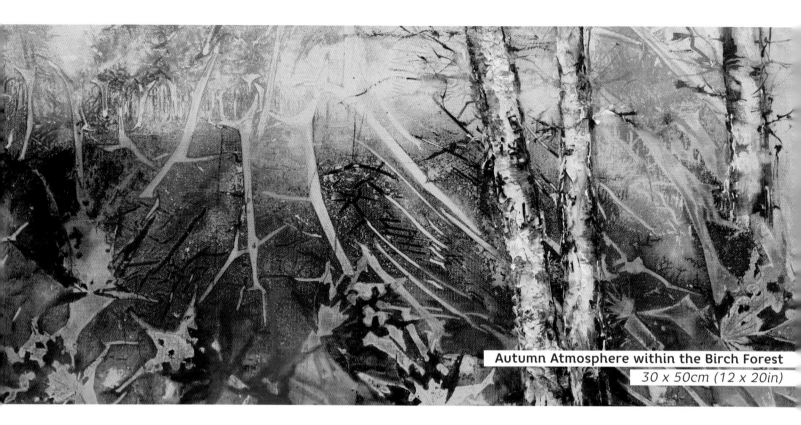

Autumn Atmosphere within the Birch Forest
30 x 50cm (12 x 20in)

Transferring (or printing) is a quick and easy way to create an interesting background for your artwork, although you will be painting over parts of it. Grasses and leaf structures, prints of ferns – all these and more – can be transferred by placing some film on the painted canvas, or watercolour paper, while still wet.

Points to remember: If you would like to preserve the leaf veins you print on to your picture, use only airbrush or fluid acrylic paints for the transfer. You will not be able to achieve a delicate print with regular acrylic paint.

However, do use acrylic paint or acrylic paint spray to prime with so that the airbrush paints don't run too far into the canvas and the colours fade.

THE TECHNIQUE STEP BY STEP

Before I explain how the technique works, I'd like you to go for a walk. Not only will it refresh you, but it is also an opportunity for you to collect the leaves needed for this technique. You will also need a canvas, acrylic paints, airbrush paints, clear plastic wrap (cellophane), a spray bottle of water and a palette knife.

1. First, I prime the canvas with yellow acrylic paint.

2. I paint some of the leaves with ochre and Brazil brown airbrush paints, then place them on the dry canvas. Next, I drizzle some ochre, dark brown and ultramarine blue airbrush paint between the leaves, and then I spray the whole canvas well with water.

3. With the painting still wet, I lay the clear plastic wrap on top and press it on to the canvas with my hands, carefully smoothing the clear plastic wrap over the paint. The idea is that the paints under the film should blend well, but the leaves stay where they are.

4. The clear plastic wrap can be removed carefully after a short drying time. The leaves should be left to dry for a few more minutes; then they too can be removed.

5. To complete the picture, I use a palette knife to add a few birch tree trunks in white and black acrylic paint.

Leaf veins

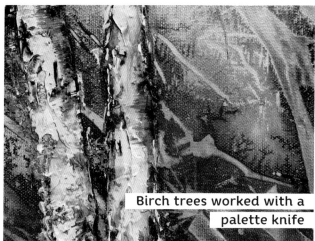

Birch trees worked with a palette knife

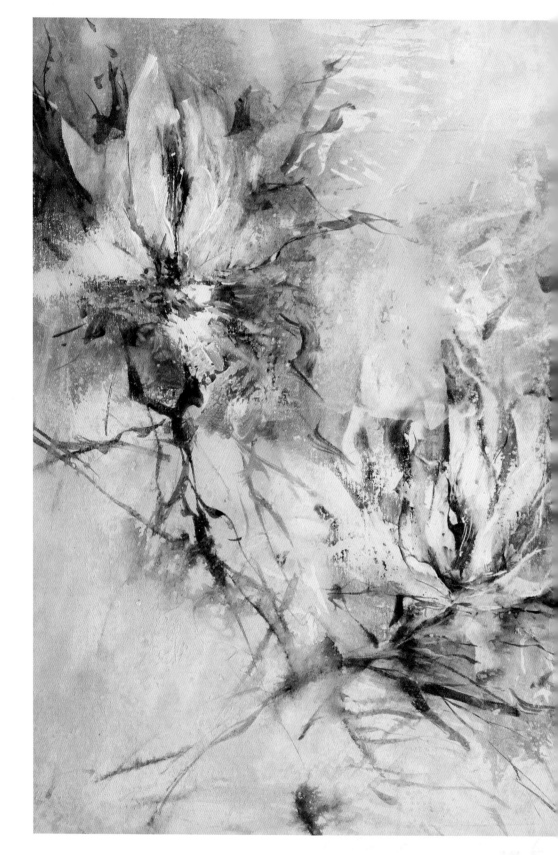

Magnolias in Spring
50 x 100cm (20 x 40in)

MAGNOLIAS IN SPRING

STEP BY STEP

MATERIALS

Canvas, 50 x 100cm
(20 x 40in)

Acrylic paint – white

Heavy body acrylic paint –
white

Fluid acrylic paint –
permanent yellow,
medium yellow, transoxide
maroon, magenta

Airbush paint –
olive green, olive brown,
deep madder red, magenta,
ultramarine blue

Gesso

Brushes/tools –
flat brush, angled brush,
palette knife

Clear plastic wrap
(cellophane)

Spray bottle of water

1. Prime the canvas with gesso. Dot in the permanent yellow and medium yellow fluid acrylic paints here and there, and the olive green, olive brown, deep madder red and ultramarine blue airbrush paints in the top left and bottom right areas of the canvas.

2. Spray these paints thoroughly with water, then place a large sheet of clear plastic wrap (cellophane) over the top left section of the canvas. Press the plastic wrap down on the canvas and smooth it over with your hands to spread the paints underneath. Leave to dry a little, then remove the film.

3. Repeat Steps 1 and 2 in the bottom right area of the painting. When dry, apply heavy body acrylic in white with a palette knife for the magnolias. Mix the transoxide maroon and magenta fluid acrylic paints, and use this mix to paint the shadows amongst the petals. Dilute the mix to achieve different shades, if necessary.

4. Use a flat brush and white acrylic paint to paint in the background. Use the white also to paint over some of the parts of the picture that you feel are slightly too bright in colour, to neutralize their vibrancy.

5. Mix olive brown and olive green airbrush paints and apply the mix to the canvas with the angled brush, to suggest the leaves and twigs around the magnolia flowers.

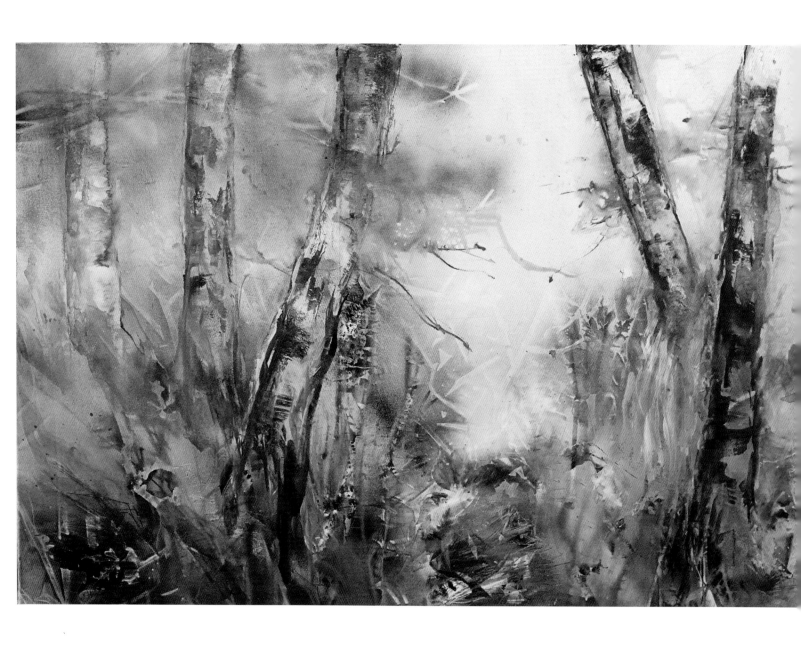

Sunshine in the Autumn Forest
70 x 100cm (28 x 40in)

SUNSHINE IN THE AUTUMN FOREST
PROJECT 2

MATERIALS

Canvas, 70 x 100cm
(28 x 40in)

Acrylic paint –
lemon yellow, white,
cobalt blue

Fluid acrylic paint –
permanent yellow,
permanent orange

Airbrush paint –
Brazil brown,
sepia, ochre

Brushes/tools –
wide flat brush, angled
brush, palette knife, rigger

Selection of leaves

Clear plastic wrap
(cellophane)

Fine modelling paste

Spray bottle of water

STEP BY STEP

1. Prime the canvas in lemon yellow, and add a little white acrylic near the top.

2. When dry, brush the leaves with fluid acrylic permanent yellow paint. Add a dot of either permanent orange or ochre airbrush paint to some of them, alternating colours with each leaf.

3. Place the leaves on the bottom third of the picture. Dab airbrush paint in brazil brown, sepia and ochre in the spaces between the leaves.

4. Spray the entire area with water and place the clear plastic wrap (cellophane) on top. Carefully smooth your hands over the film to mix the colours, taking care not to move the leaves.

5. Allow to dry for a few minutes, then remove the film – don't throw it away yet. Let the leaves dry for five to ten minutes, then remove them as well.

6. With the film used earlier, still slightly wet with paint, press it briefly into the upper third of the picture to indicate a few faded leaves. Smooth in the tree trunks with modelling paste.

7. When dry, allow airbrush paint in Brazil brown to flow over the tree trunks on the right-hand side, and sepia over those on the left. Use the rigger to paint suggestions of branches between the trees.

8. Mix a thin glaze with cobalt blue and white acrylic paint and water, and allow it to flow over the upper tree trunks like mist.

9. Use a wide flat brush to apply blue acrylic paint to some of the area of the printed leaves that represent the forest floor.

The picture without the blue glaze applied later (see Step 8).

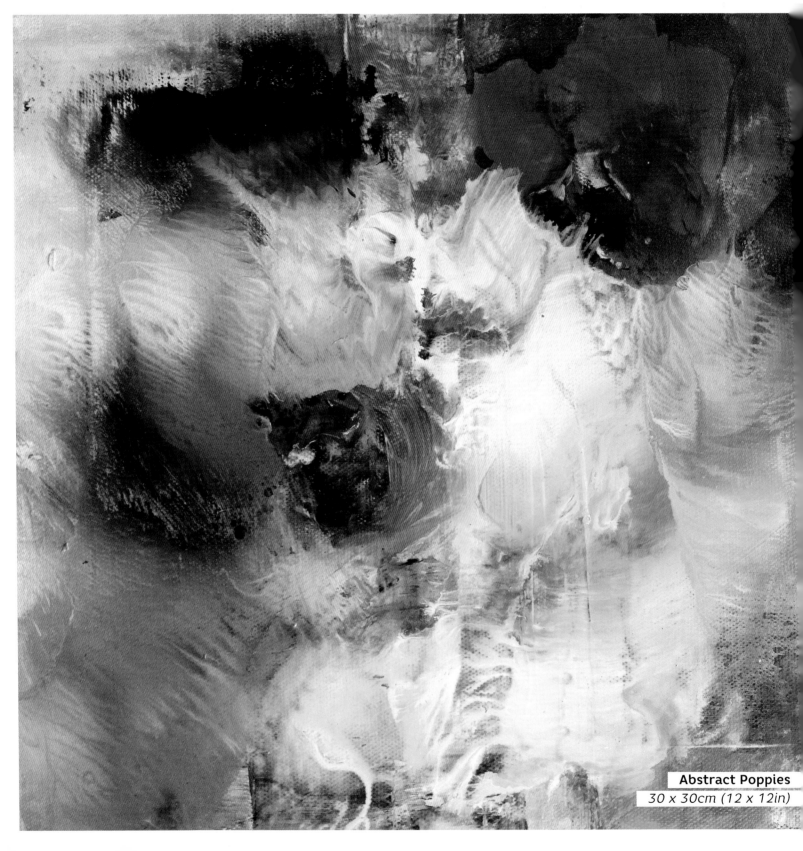

Abstract Poppies
30 x 30cm (12 x 12in)

ABSTRACT POPPIES
PROJECT 3

MATERIALS

Canvas, 30 x 30cm
(12 x 12in)

Acrylic paint –
Hooker's green, May green,
white, black, lemon yellow,
cadmium orange,
permanent red,
cobalt blue, turquoise

Fluid acrylic paint –
permanent red,
transoxide maroon

Gesso

Brushes/tools –
flat brush, angled brush

Clear plastic wrap
(cellophane)

Spray bottle of water

1. Prime the canvas with gesso. Use the flat brush to paint small areas of the canvas in all the different shades of acrylic paints.

2. Spray a little water over the picture, then place the clear plastic wrap (cellophane) over the wet canvas. Smooth over with your hands; you will be able to see through the film how the colours spread. You can control this process if you wish by changing the movement of your hands.

3. Now remove the film. When the picture has dried, use the angled brush and permanent red fluid acrylic paint to indicate a poppy in the top right-hand corner. Add a dark background around it in transoxide maroon.

4. Highlight the middle of the flower with a dot of black acrylic paint.

TIP

I used only acrylic paint for this print, so the printed areas are more solid.

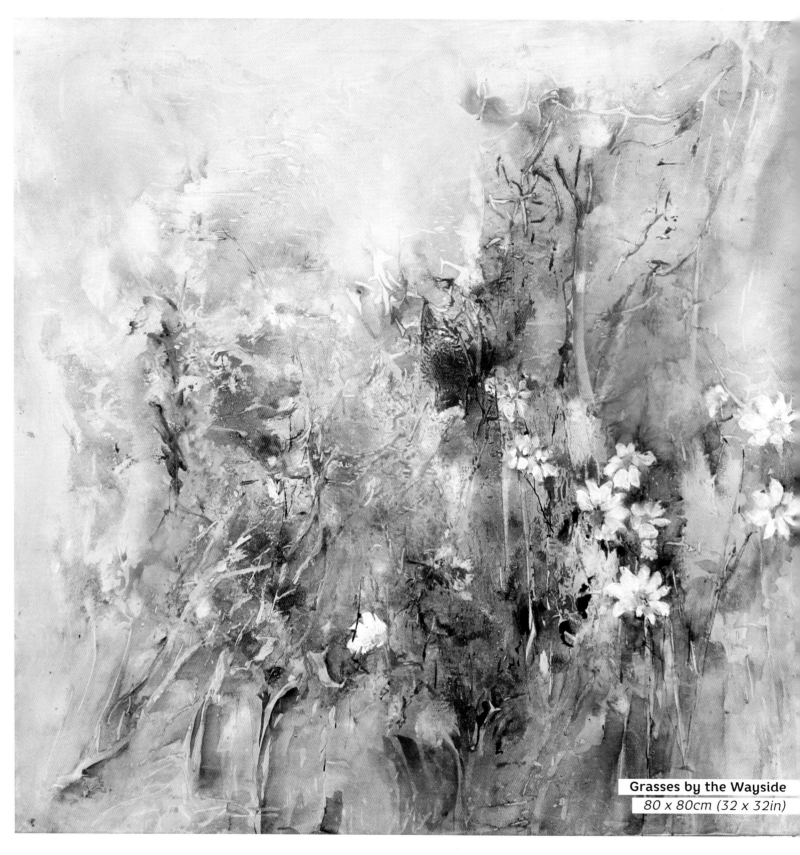

Grasses by the Wayside
80 x 80cm (32 x 32in)

GRASSES BY THE WAYSIDE
PROJECT 4

STEP BY STEP

MATERIALS

Canvas, 80 x 80cm (32 x 32in)

Acrylic paint – white

Airbush paint –
cobalt blue, ultramarine blue, pale yellow, orange, magenta, olive brown, olive green, white

Gesso

Brushes/tools –
flat brush, rigger

Clear plastic wrap (cellophane)

Fine modelling paste

Spray bottle of water

1. Prime the canvas first with gesso. Drip plenty of airbrush paint in cobalt blue, ultramarine blue, pale yellow, a little orange, magenta, olive brown and olive green on to the canvas.

2. Add dots of white airbrush paint here and there. Carefully spray the picture with water then place the clear plastic wrap (cellophane) on top. Brush your hands lightly over the film to spread and blend the paints underneath.

3. Leave to dry for about ten minutes, then carefully peel the film off the picture. Leave until completely dry.

4. Now transform a few areas in your picture into flowers with the flat brush, using your chosen airbrush paints. Use a palette knife to add a few little marguerite daisies in modelling paste – I have added these on the right-hand side of my picture.

5. Mix together olive brown and olive green and use them to darken a few green areas, namely in the bottom section of the canvas. Then, take the rigger and add a few stalks to the flowers with a quick, sweeping motion.

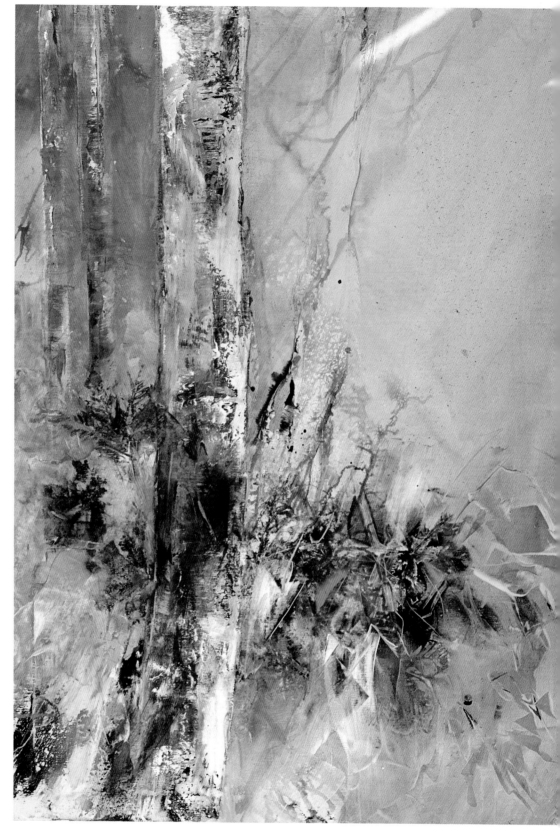

Sunshine Yellow in the Forest
70 x 100cm (28 x 40in)

SUNSHINE YELLOW IN THE FOREST
PROJECT 5

STEP BY STEP

MATERIALS

Canvas, 70 x 100cm
(28 x 40in)

Acrylic paint –
lemon yellow, process
yellow, cobalt blue, white

Fluid acrylic paint –
permanent yellow,
medium yellow, white

Airbrush paint –
ochre, Brazil brown, sepia,
olive brown

Brushes/tools –
flat brush, angled brush,
rubber spatula,
palette knife

Modelling paste

Clear plastic wrap
(cellophane)

Spray bottle of water

1. Prime the upper half of the canvas in lemon yellow acrylic paint and the lower half in process yellow. Leave to dry.

2. Using the palette knife and modelling paste, smooth the shape of a large trunk down the centre of your canvas. Indicate a few narrower trunks to the left of it in the same way.

3. Leave until completely dry. Brush the leaves in ochre, Brazil brown, sepia and olive brown airbrush paints. Arrange the leaves horizontally over the picture in the bottom third of the canvas.

4. Now apply generous quantities of acrylic paint, directly from the bottles, in permanent yellow, medium yellow and white over the leaves with the rubber spatula. Fill any remaining gaps with airbrush paints in ochre and Brazil brown.

5. Spray carefully with plenty of water and place the plastic wrap (cellophane) on top. Smooth your hands over the film. You'll be able to see quite clearly how the paints blend underneath.

6. Allow to dry for a few minutes before removing the film. Leave the leaves for a few more minutes, then remove these as well.

7. Shade the tree trunk with a flat brush, using sepia and Brazil brown airbrush paints. Use the angled brush and these browns once more to indicate a few branches in the picture.

8. Mix cobalt blue acrylic with a little white acrylic and paint a small section of sky in the top left of the picture. Add a few more spots of this colour elsewhere in the picture for balance.

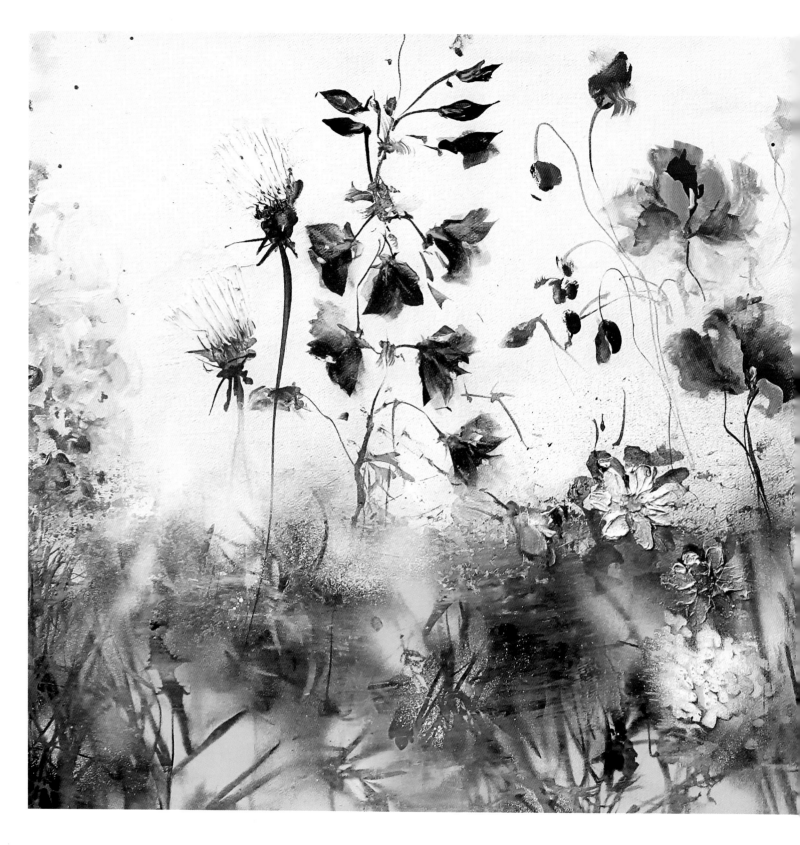

SPRAY PAINT TECHNIQUE

Acrylic spray paint is a wonderful form
of artistic expression and is a material
that I never want to be without. This
method allows me to produce paintings
with highly diverse results.

THE TECHNIQUE IN FOCUS
SPRAY PAINT TECHNIQUE

As I mentioned earlier, acrylic spray paints are the latest edition to my usual paint palette. Combined with the natural materials you have collected, these sprays offer up undreamt-of creative possibilities in both texture and mood! Once you are familiar with the method, you will undoubtedly find your awareness increases on your walks out and about for inspiration, and you'll find yourself looking for unusual shapes that inspire you and can be used for your own creations. Acrylic and watercolour paintings that lack a 'certain something' can be tweaked and finished off in all sorts of ways with the help of spray paint. Do try it!

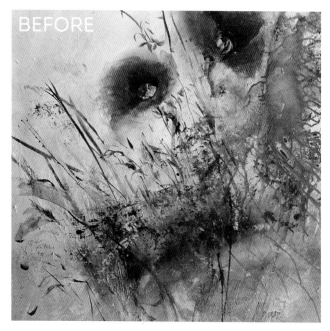

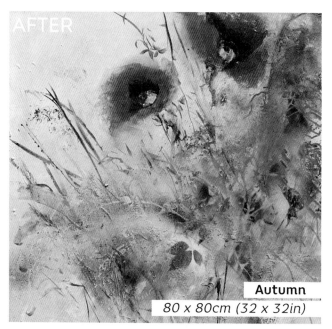

Autumn
80 x 80cm (32 x 32in)

Before
The part of the meadow that is already an autumnal brown looks a little busy and choppy.

After
A soft, calmer effect is achieved by spraying the picture with acrylic paint in dark brown and sand, and then adding a few leaves and grasses.

THE TECHNIQUE STEP BY STEP

My example here shows you how quickly and easily standard acrylic paintings can be changed using spray paints.

1. Prime the upper half of the canvas with acrylic paints in white and various shades of yellow, and the lower half in various shades of green.

2. Briefly press your chosen grasses, stalks and leaves, then arrange them decoratively on the picture. Arrange tiny stones in little piles with a few daisy heads on them.

3. Spray the picture with acrylic spray paint in dark green.

4. Now spray acrylic paint in pale yellow and pale green at selected points over the grasses.

5. Add a few accents to the flowers in light blue acrylic spray paint.

6. Leave to dry for a few minutes then remove the grasses, leaves and stones from your canvas. I have also sprayed a little acrylic paint in pale yellow in the top-right corner, to brighten and balance the overall composition.

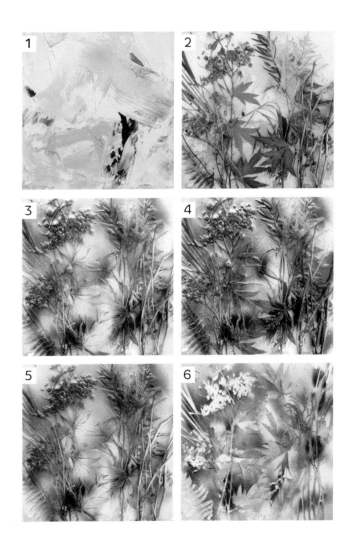

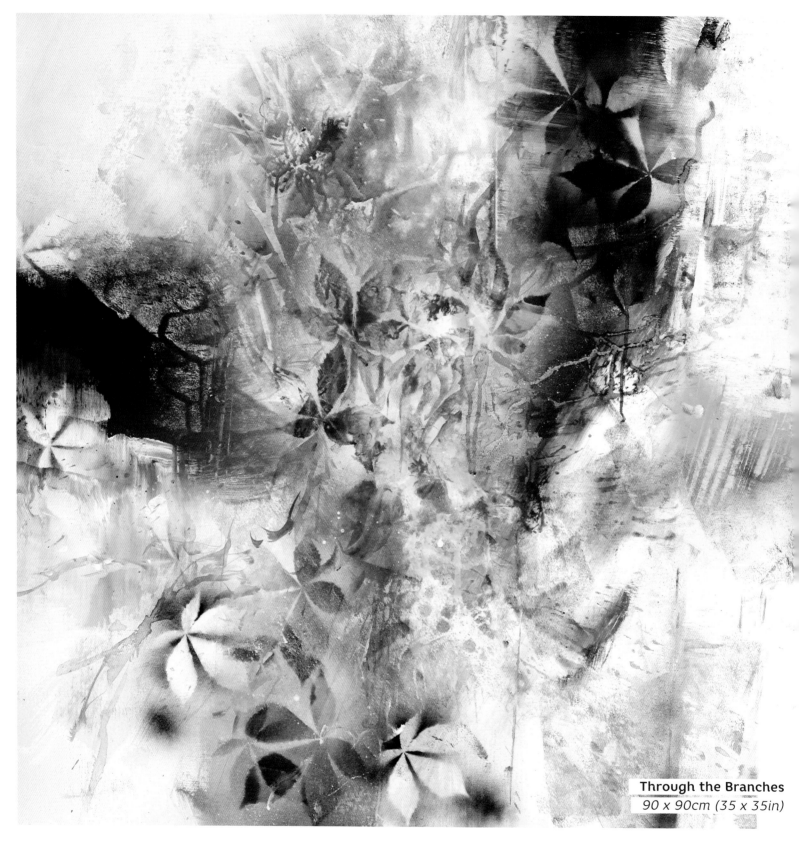

Through the Branches
90 x 90cm (35 x 35in)

THROUGH THE BRANCHES

PROJECT 6

STEP BY STEP

1. Using a wide flat brush, generously apply process yellow, May green and white acrylic paints on to the canvas. Take care that they are not too runny. Leave some areas of the canvas white – I chose to keep the corners bare. Paint parts of the canvas in black acrylic paint. Allow to dry for a few moments.

2. Using a smaller flat brush, paint a few strokes over the painting in May green acrylic paint: I worked these lines into the right-hand side of the painting to balance the colours in the centre. Dilute white acrylic paint and allow to run across the picture. Spray water on to the paint and let it run. Using a large plastic spatula, mix a few areas of the paint directly on the canvas. Leave to dry.

3. Paint a few chestnut leaves and twigs with olive brown and olive green airbrush paint then place them on to the canvas. Apply the airbrush paints to the canvas around the leaves, and then do the same with the fluid acrylic paints in permanent yellow and medium yellow. Spray the leaves with water. Now press the clear plastic wrap (cellophane) on to the canvas. Allow the paints underneath to blend well, using your hands to gently smooth out the colours. Each leaf should be covered in paint.

4. Allow to dry for a few moments, then lift off the film. Leave the leaves and twigs on the canvas for a little longer. Pressing down on them emphasizes their patterns and textures in the paint. Carefully remove them after a few minutes.

5. When dry, place fresh leaves on the picture and press down on them with your hand. Now spray the leaves with paint used for your main background. This way, the background colour is retained.

6. Calm areas are created by painting any free spaces in white and yellow acrylic paint. Apply the white paint first, then add touches of yellow where you see fit.

MATERIALS

Canvas, 90 x 90cm (35 x 35in)

Acrylic paint – process yellow, black, May green, white

Fluid acrylic paint – permanent yellow

Airbrush paint – olive brown, olive green

Acrylic spray paint – white, pale yellow, black

Brushes/tools – flat brushes, plastic spatula

Selection of leaves, twigs

Clear plastic wrap (cellophane)

Spray bottle of water

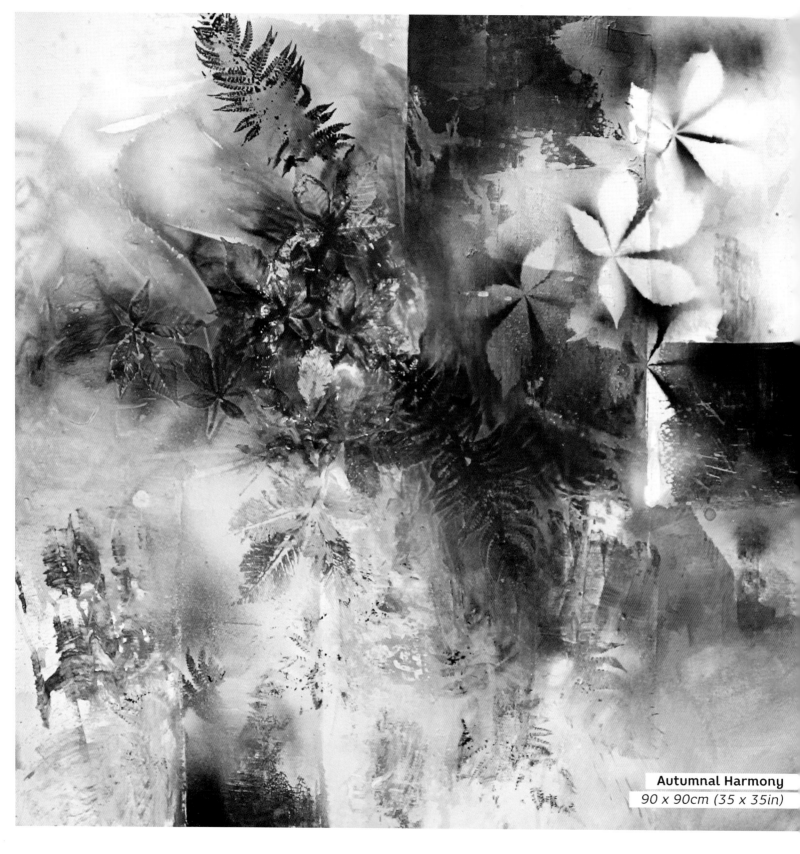

Autumnal Harmony
90 x 90cm (35 x 35in)

AUTUMNAL HARMONY
PROJECT 7

STEP BY STEP

MATERIALS

Canvas, 90 x 90cm
(35 x 35in)

Acrylic paint –
white, black, primary
yellow, cadmium orange

Fluid acrylic paint –
transoxide maroon, medium
yellow, permanent red

Airbrush paint –
Brazil brown,
deep madder red

Acrylic spray paint –
white, black, pale yellow

Brushes/tools –
flat brush, angled brush,
palette knife

Selection of autumn leaves
(e.g. maple, chestnut, fern)

Preserving spray

Clear plastic wrap
(cellophane)

Spray bottle of water

1. Prepare the leaves by pressing them and sealing them with preserving spray. Using a wide flat brush, apply areas of the canvas with undiluted black and white acrylic paint. Note how I have painted these as solid blocks of colour.

2. When dry, paint a few areas in primary yellow acrylic paint. Now paint the various leaves well in transoxide maroon fluid acrylic paint and place them diagonally on to the picture.

3. Dot Brazil brown and deep madder red airbrush paint around the leaves with an angled brush, adding touches of yellow medium and permanent red acrylic paint over the top. Spray the entire area with water.

4. Now place the clear plastic wrap on top. Smooth your hands over the film so the colours mix well underneath – but make sure the leaves do not move. Each leaf should be well covered with paint. There must be no white spaces left on the canvas.

5. Leave the picture with the film on it to dry for about ten minutes, then carefully lift off the film. The leaves should be left to dry in the paint a little longer before also being removed.

6. When the picture is dry, place a few preseved leaves on to the canvas and spray with black acrylic spray paint. If some areas seem too dark, spray a little pale yellow acrylic paint over the leaves too.

TIP

The unusual shape of maple leaves makes them ideal for this project.

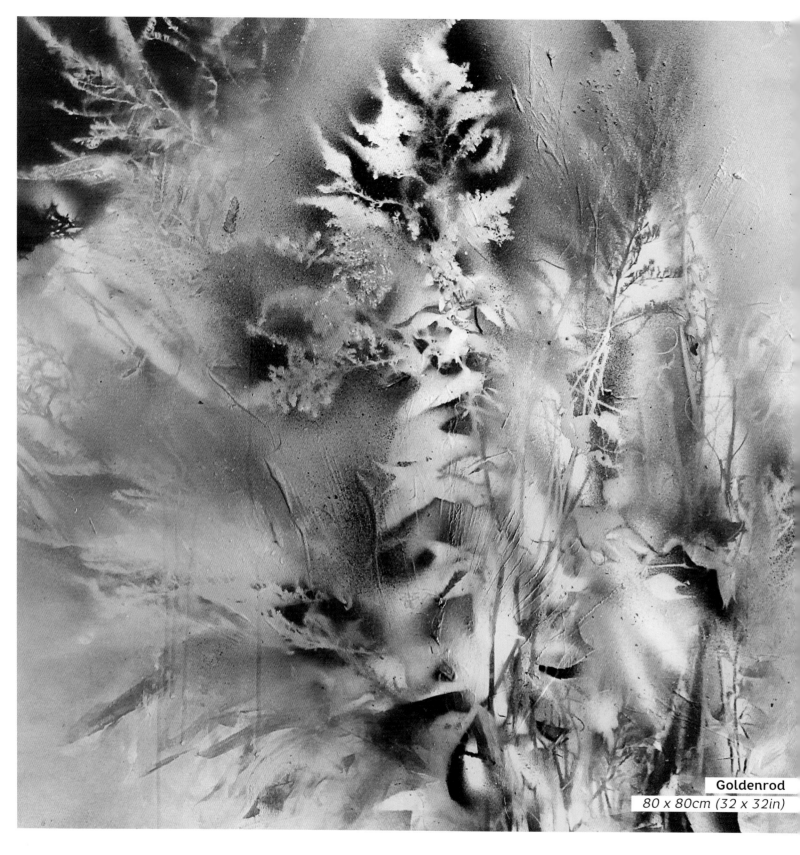

Goldenrod
80 x 80cm (32 x 32in)

GOLDENROD
PROJECT 8

STEP BY STEP

MATERIALS

Canvas, 80 x 80cm
(32 x 32in)

Acrylic paint –
lemon yellow,
Indian yellow, May green,
white, Hooker's green

Acrylic spray paint –
dark green, pale yellow,
dark yellow, pale turquoise

Brushes/tools –
flat brush, palette knife

Goldenrod with leaves,
few long stalks

Pieces of cardboard

Spray bottle of water

1. Place the goldenrod between two pieces of cardboard and press for a few minutes; do the same with the long stalks. You could use young branches of the Virginia creeper – its branches are very soft and easy to bend and press. Make sure you remove the leaves. Leave these to dry.

2. Use a wide palette knife to apply acrylic paint in lemon yellow and Indian yellow to parts of the canvas.

3. Mix May green acrylic paint with a little white to make a soft, pale green. Take a flat brush and paint the rest of the canvas with this mixed pale green acrylic paint, along with pure May green and Hooker's green. Leave to dry.

4. Dilute the lemon yellow and Indian yellow acrylic paints with a little water. Let the two diluted paints flow over the dry picture. Leave to dry.

5. Now place the dried goldenrod on the yellow areas of the canvas and arrange the stalks around it. Carefully spray around the goldenrod and stalks in dark green acrylic spray paint. If any areas look a little dark, immediately spray with some pale or darker yellow, or pale turquoise. You can easily make corrections by spraying on new paint, but the flower and stalks must stay where they are. Remove them when you are satisfied with the results.

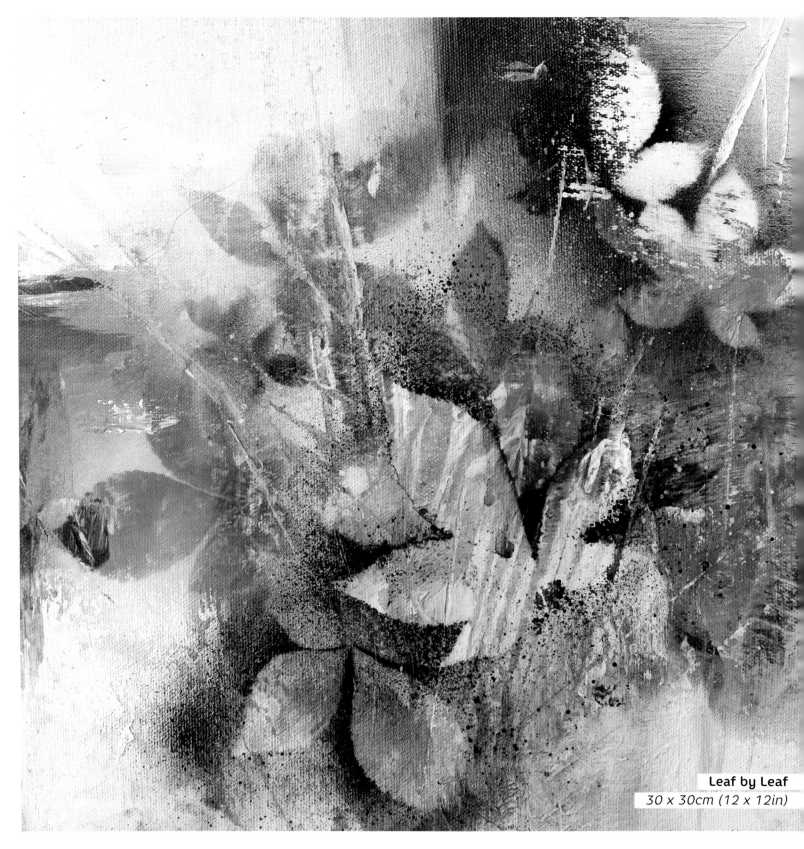

Leaf by Leaf
30 x 30cm (12 x 12in)

LEAF BY LEAF
PROJECT 9

STEP BY STEP

MATERIALS

Canvas, 30 x 30cm
(12 x 12in)

Acrylic paint –
white, lemon yellow, Indian
yellow, May green,
Hooker's green, black

Acrylic spray paint –
black, pale yellow

Brushes/tools –
flat brush, rubber spatula

Selection of leaves
(e.g. chestnut, maple,
Virginia creeper)

1. With the flat brush, paint sweeping strokes on the canvas in white, lemon yellow and Indian yellow acrylic paints. Allow the picture to dry for a few moments.

2. Paint a few areas in May green, Hooker's green and black acrylic paint. Now take the rubber spatula and draw a few branch-like structures throughout the picture.

3. Arrange the leaves anywhere you like on the canvas to create interesting shapes! If the picture's background is light, spray these areas with acrylic paint in dark green. If it is dark, use a light yellow spray paint.

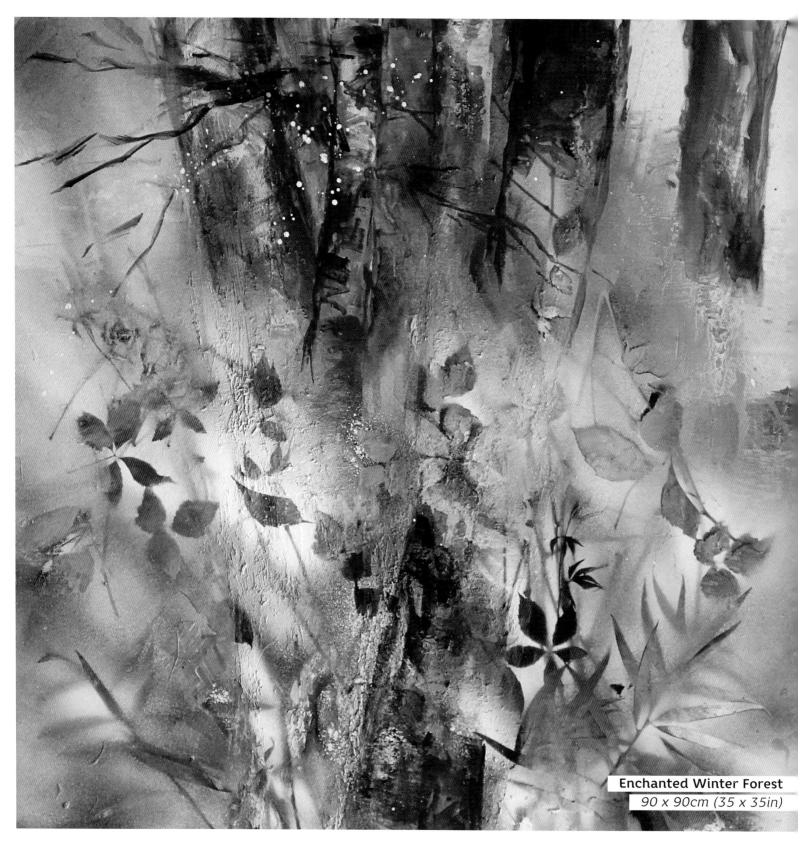

Enchanted Winter Forest
90 x 90cm (35 x 35in)

ENCHANTED WINTER FOREST
PROJECT 10

STEP BY STEP

MATERIALS

Canvas, 90 x 90cm
(35 x 35in)

Acrylic paint –
white, ultramarine blue,
cobalt blue, permanent
orange, black

Heavy body acrylic paint –
white

Airbrush paint –
deep madder red

Acrylic spray paint –
dark green, pale blue, pale
yellow, white

Gesso

Brushes/tools –
flat brush, rubber spatula,
palette knife

Selection of leaves, stalks

Spray bottle of water

1. After priming the canvas with gesso, paint in different shades of blue acrylic paint using a large flat brush.

2. When dry, apply heavy body white with the spatula for the tree trunks. Again, leave to dry.

3. Use a palette knife to draw acrylic paint in permanent orange across the picture.

4. Apply deep madder red airbrush paint to a few areas, then spray with water and allow the paint to run into some of the orange areas.

5. Shade the tree trunks in black acrylic paint. Draw a few branches on the picture.

6. When dry, arrange the leaves and stalks over the bottom half of the picture, making sure they are lying flat.

7. Spray dark green acrylic spray paint around the plants. Immediately spray some of the plant areas in pale blue acrylic spray paint, some in pale yellow, and others in white. Leave to dry for a few minutes, then remove the leaves and stalks.

Natural templates reveal what lies beneath.

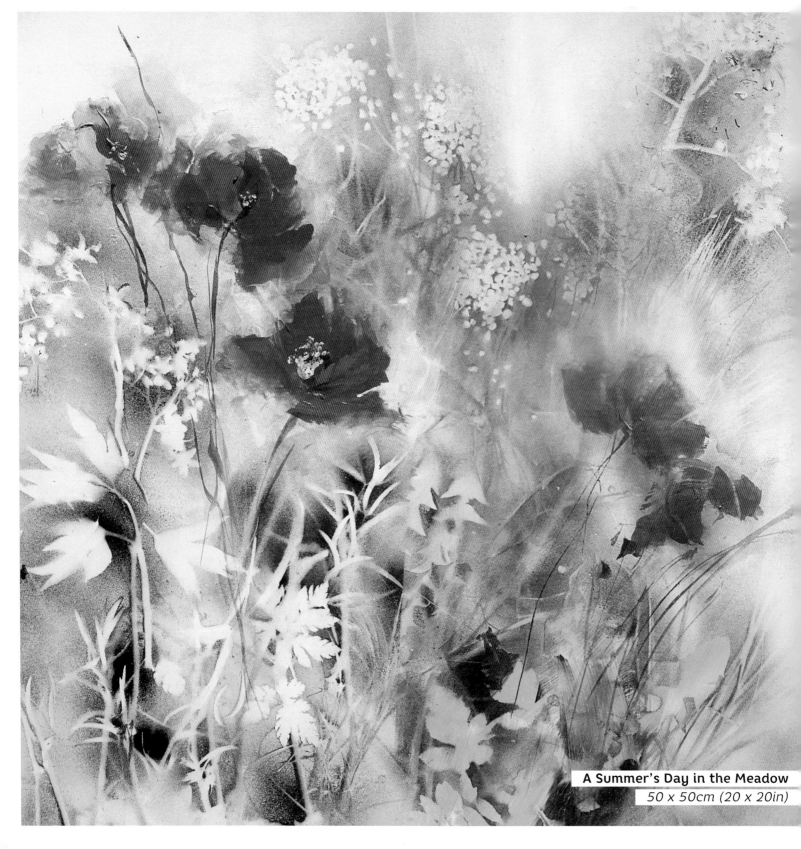

A Summer's Day in the Meadow
50 x 50cm (20 x 20in)

A SUMMER'S DAY IN THE MEADOW
PROJECT 11

STEP BY STEP

MATERIALS

Canvas, 50 x 50cm
(20 x 20in)

Acrylic paint –
permanent orange, lemon
yellow, process yellow,
Indian yellow, May green,
Hooker's green, white

Fluid acrylic paint –
permanent red,
transoxide maroon

Acrylic spray paint –
dark green, pale yellow,
pale green

Gesso

Brushes/tools –
flat brush, angled brush

Selection of poppies,
daisies, pebbles,
leaves, stalks

Paper towels

1. Prime the canvas with gesso. When dry, begin by applying a soft pale yellow acrylic paint to the canvas with a wide flat brush, working from the top. As you make your way down the canvas add strokes of process yellow followed by a little Indian yellow, to create a soft transition in colour.

2. Paint the lower third in May green and Hooker's green acrylic paints. Leave to dry. Then, add a few dots of white acrylic paint between the different shades of yellow.

3. Paint the poppies in permanent orange acrylic paint and press them on to the picture. Leave for a few minutes, then carefully peel them off of the canvas. Finish the poppies in permanent red and transoxide maroon fluid acrylic paint. Dot a little process yellow in the centres of the flowers with your finger tip. Now leave it all to dry well.

4. Arrange stalks and leaves on the painting wherever you like, ensuring that they are lying flat on the canvas. Arrange the pebbles and daisy heads on the white and some of the yellow areas on the picture to create flower-like shapes. Cover the poppies with paper towels dampened with water to prevent the spray paint from settling on them. Moistening the paper towels makes them heavier too, so they won't be blown away by the acrylic spray.

5. Now carefully spray the leaves and stalks with dark green acrylic spray paint. Instantly add yellow and light green spray paint over the top, here and there. Make sure that the initial spray of dark paint is not allowed to dry too much before the lighter colour is added, else the colours will not be able to blend effectively!

6. Remove the materials that you have placed on the finished picture. To finish, paint the stalks of the daisies in Hooker's green with the angled brush.

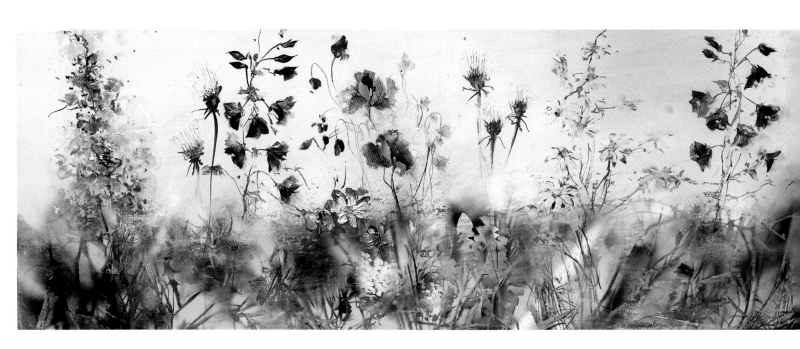

In Rank and File –
delicate flowers in a row
50 x 130cm (20 x 50in)

IN RANK AND FILE
PROJECT 12

MATERIALS

Canvas, 50 x 130cm
(20 x 50in)

Acrylic paint –
May green, Hooker's green

Fluid acrylic paint –
magenta, transoxide
maroon, ultramarine blue,
permanent yellow

Airbrush paint –
olive brown, olive green

Acrylic spray paint –
dark green, pale green,
pale blue

Gesso

Brushes/tools –
flat brush, angled brush,
rigger

Selection of grasses,
stalks, leaves, pebbles

1. Prime the canvas with gesso. When dry, use the fluid acrylic paints to paint pink poppies, dandelions, marguerite daisies and bluebells – in that order – with an angled brush and rigger on to the upper two-thirds of the picture. Paint only the flower heads for now.

2. Paint the lower third in May green and Hooker's green acrylic paints.

3. When the picture is dry, arrange the flat grasses, stalks, leaves and pebbles within the green areas in whatever way you like. Start by spraying these areas in dark green acrylic paint, and then immediately spray pale green and touches of pale blue over this.

4. Allow to dry for a few moments, then remove the sprayed materials.

5. Blend the olive brown and olive green airbrush paints to make a dark green, and use the angled brush and rigger to paint in the flower stalks.

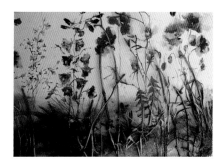

A red-dominated version of the rows of flowers.

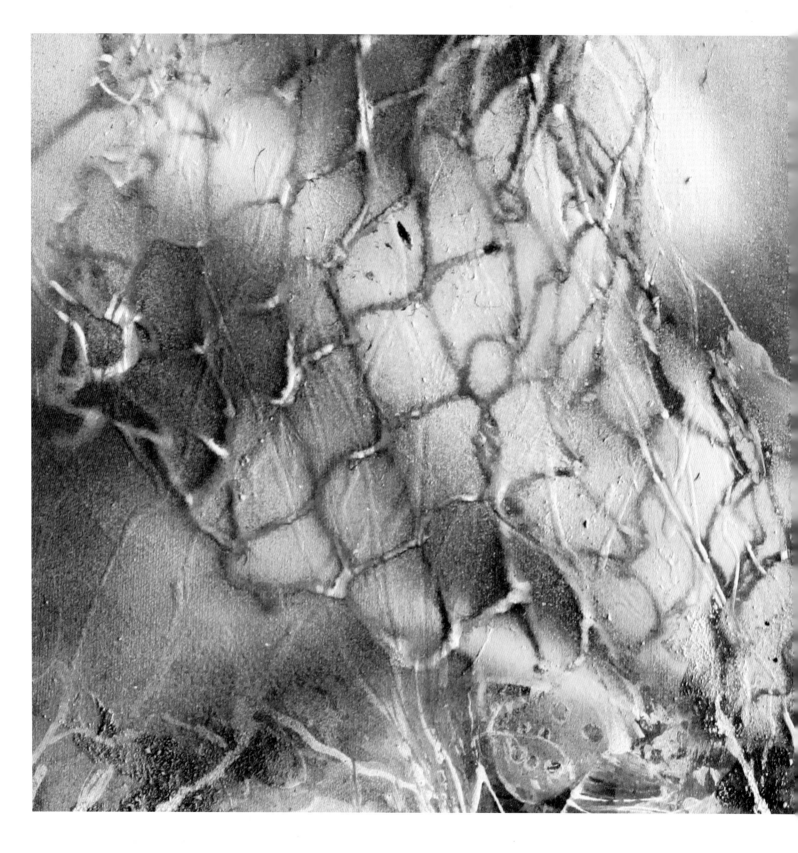

PHOTO TRANSFER

Photographed images transferred on to the picture are a quick and easy alternative to drawing when you want to represent something more precisely.

THE TECHNIQUE IN FOCUS
PHOTO TRANSFER

How often does a practised painter become aware of new techniques on an art course! As I love to paint animals but dislike the initial sketching process – yet recognize the importance of depicting their shapes more accurately than botanical forms – I had tried my hardest to get out of drawing them by gluing posters of my chosen animals on to the canvas, or by tracing pictures or working with a projector. But then, on this art course, I discovered something new: photo transfer.

This interesting and easy method really will make your life easier. However, the challenge is to not simply leave the image as it is, but to paint over it correctly and create the right background.

You can use either a black-and-white print photo of your subject or a colour copy. What is important is that it is from a laser printer, otherwise it won't transfer properly. In addition, the copier paper should not be more than 80gsm (20lbs).

Before you stick the copy on to your painting surface, tear a thin, irregular edge around the main image. This will create a softer edge around the picture, making it easier to paint over the intersections between canvas and copy, and also hide the edges so that the presence of a printed image is much less obvious. In addition, remember to glue the image on face down! if you want to use an image with writing on it, you will have to photocopy or print it the other way around (like a mirror image).

With this technique, you will be able to paint a perfect reproduction of your pet or chosen subject. Even the wrong gap between the eyes is enough to change a model's semblance to the original; with photo transfer, you won't have any problems trying to capture those exact details in your beloved pet or loved one's features.

Giacomo
30 x 30cm (12 x 12in)

Gina
30 x 30cm (12 x 12in)

Cappuccino
30 x 30cm (12 x 12in)

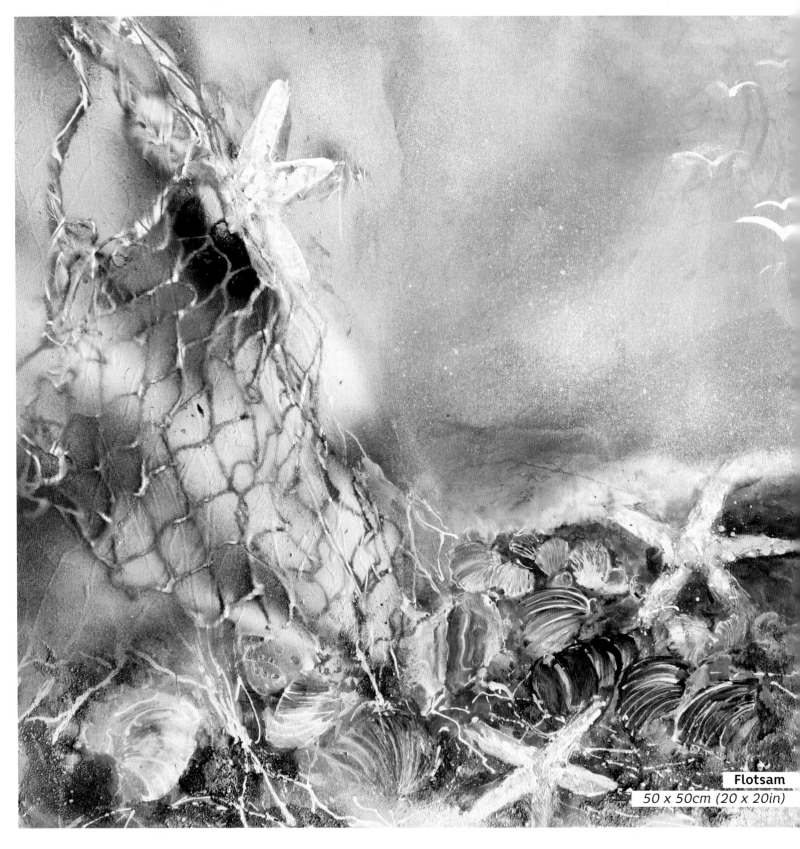

Flotsam
50 x 50cm (20 x 20in)

FLOTSAM
PROJECT 13

MATERIALS

Canvas, 50 x 50cm
(20 x 20in)

Acrylic paint –
white, pale blue,
ultramarine blue, ochre,
dark brown

Acrylic spray paint –
black, dark blue, pale blue,
beige, white

Laser-printed copies –
flotsam beach (including
starfish, shells, snails),
starfish

Beach objects –
netting, coarse sand

Transfer glue

Brushes/tools –
flat brush, angled brush

Soft cloth

Household sponge

Acrylic binder

Spray bottle of water

Hairdryer (optional)

STEP BY STEP

1. Prime the canvas with white acrylic paint. Tear unevenly around the edges of the laser copy of the flotsam beach, and apply plenty of transfer glue to the front and to the area where you want the image to go. Place the copy on the canvas, photo side facing down, and smooth the paper flat with a soft, dry cloth. Stick the laser copy of the starfish a little higher up on the left; this will later be half covered by the 'fishing' net. You can then either leave the picture to dry for a day, or hold a hairdryer over it for about ten minutes or so.

2. Moisten the pasted images with warm water and then scrub them with the rough side of a household sponge until the top layer of paper is removed.

3. Paint over the shells, snails and starfish in the appropriate acrylic paints. When dry, paint the rest of the picture with pale blue acrylic paint, including the areas between the various objects. Shade these small areas with a little ultramarine blue and ochre acrylic paint. Leave to dry.

4. Apply a little acrylic binder to some of the areas between the shells and sprinkle a little coarse sand over it.

5. Dilute some white acrylic paint with a little water and run this glaze over the upper half of the picture with the pale blue acrylic paint. When dry, drape a net (an old shopping net bag will do) over the left side of the picture. Scatter a little sand across bottom of the picture. Spray the net and sand with black acrylic paint, and then over this spray some of the areas with dark blue, pale blue, beige and white acrylic spray paint.

6. Pour some white acrylic paint into a little bottle with a fine tip, and use this to carefully squeeze little drops of white onto some parts of the net to highlight.

7. Using the angled brush and white acrylic paint, add a few seagulls to the right side of the picture.

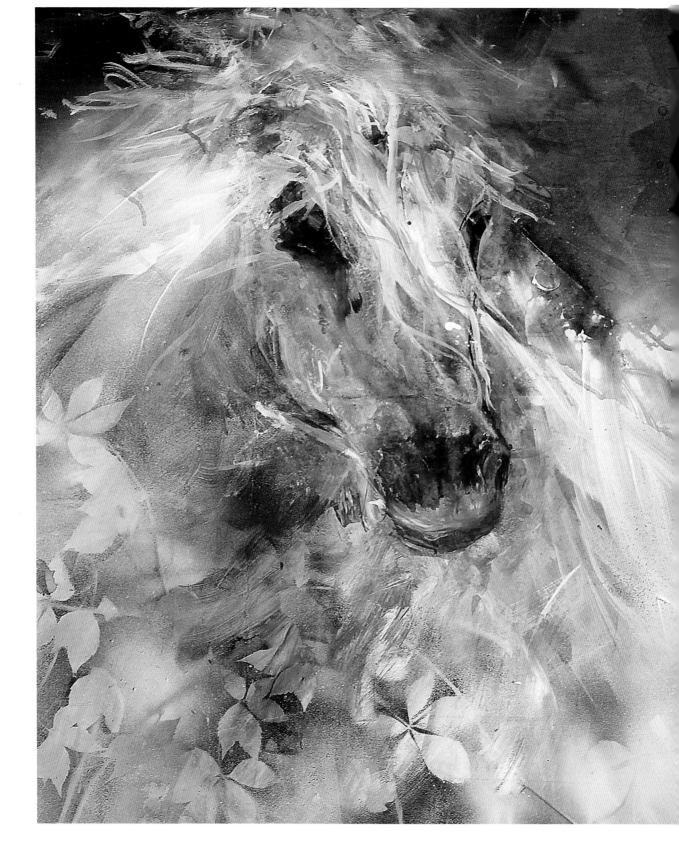

Wild Magic
70 x 90cm
(28 x 35in)

WILD MAGIC
PROJECT 14

STEP BY STEP

MATERIALS

Canvas, 70 x 90cm
(28 x 35in)

Acrylic paint –
black, white, ochre

Acrylic paint spray –
dark brown, white

Gesso

Transfer glue

Brushes/tools –
flat brush, angled brush

Selection of leaves, stalks

Soft cloth

Household sponge

Laser-printed copy
of a horse,
approx. 50 x 60cm
(20 x 24in)

Hairdryer (optional)

1. Prime the canvas with gesso and leave to dry. Tear unevenly around the edge of the laser copy of the horse. Brush the canvas and the front of the image generously with transfer glue then immediately glue it to the canvas, photo side facing down. Carefully brush a soft, dry cloth over it to remove any bubbles. The adhesive must not leak over the edges either. Leave to dry completely or hold a hairdryer over the canvas for about ten minutes or so.

2. Moisten the paper well with warm water and then use the rough side of a household sponge to rub away the top layer of paper. Leave to dry.

3. Enhance the outlines of the horse using an angled brush and black acrylic paint. Do the same with the eyes, nostrils and ears.

4. Mix together black and white acrylic paint to make a dark grey. Paint the background from the top left in black acrylic paint, and from the right and below in the dark grey. Paint the areas in between with ochre.

5. Place the pressed leaves and stalks on the bottom third of the picture. Spray them first in dark brown acrylic spray paint followed by white. Leave to dry for a few minutes, then remove the leaves and stalks.

6. Using the flat brush, paint in the horse's head with ochre and grey acrylic paint. Shape the eyes and nostrils using the flat brush and black acrylic paint, and add a few light spots in white acrylic paint.

7. Dilute some white acrylic paint with water and paint the mane with the angled brush, using sweeping strokes. Spray the mane with water, and let the white paint run into some parts of the picture.

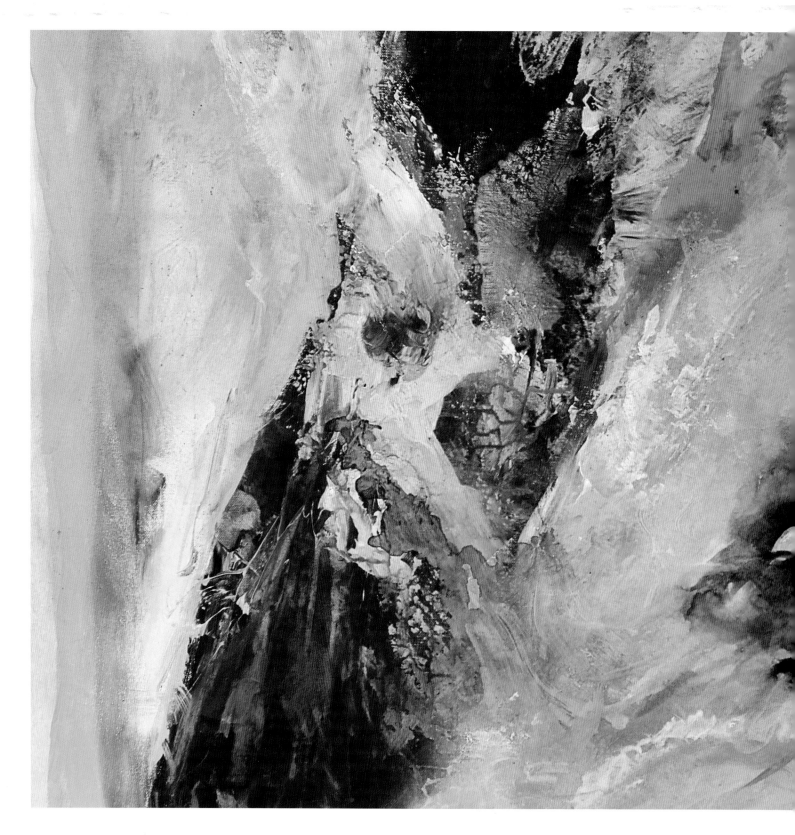

PAINTING KNIFE TECHNIQUE

Whether using modelling paste or sand, textured materials are perfect for reproducing natural textures in countless different ways.

PAINTING KNIFE TECHNIQUE

The focus of this section is on the use of spatulas and palette knives. What makes the pictures created with this technique so special is that the main motif rises from it like a relief. Liquid paints accumulate in the dips, creating unusual shapes and areas that cannot be achieved by any other method. The bark-like texture of tree trunks and eye-catching quality of flowers and leaves in particular are made more sculptural when painted using this method. Backgrounds are also more varied.

Paint is applied more solidly with a palette knife or spatula. The easiest way to create really coarse textures is to add sand to the paint. However, you can also use ready-made modelling paste from craft stores.

TIP

Not only do large structures in your paintings, such as bark or soil, benefit from the use of modelling paste, the paste also enhances the charm and three-dimensionality of the delicate flowers of a magnolia tree. Sometimes, a little contrast is just the thing.

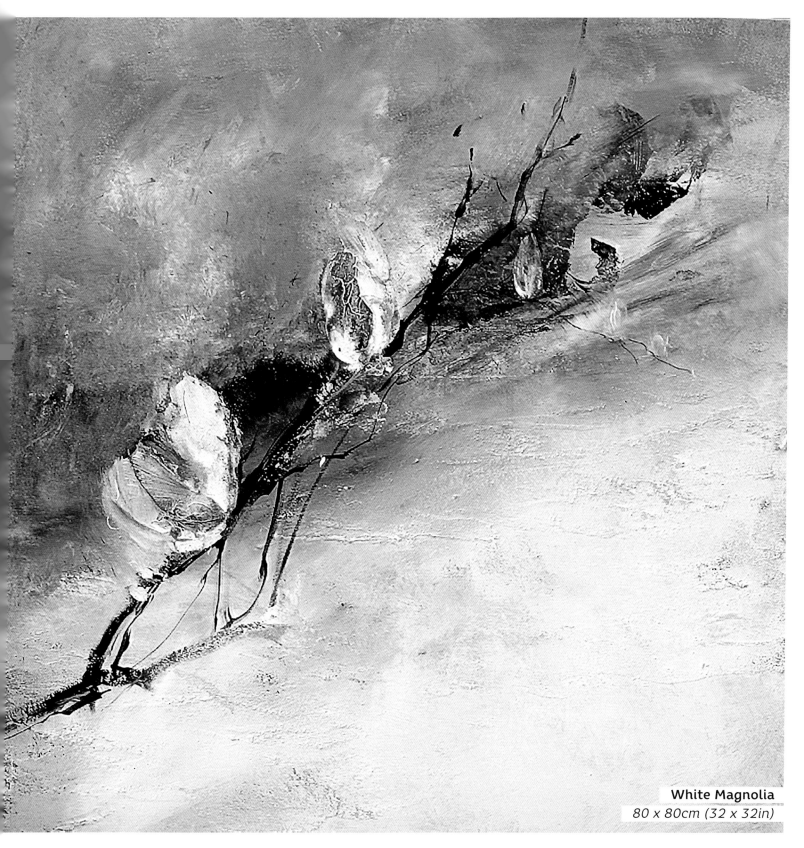

White Magnolia
80 x 80cm (32 x 32in)

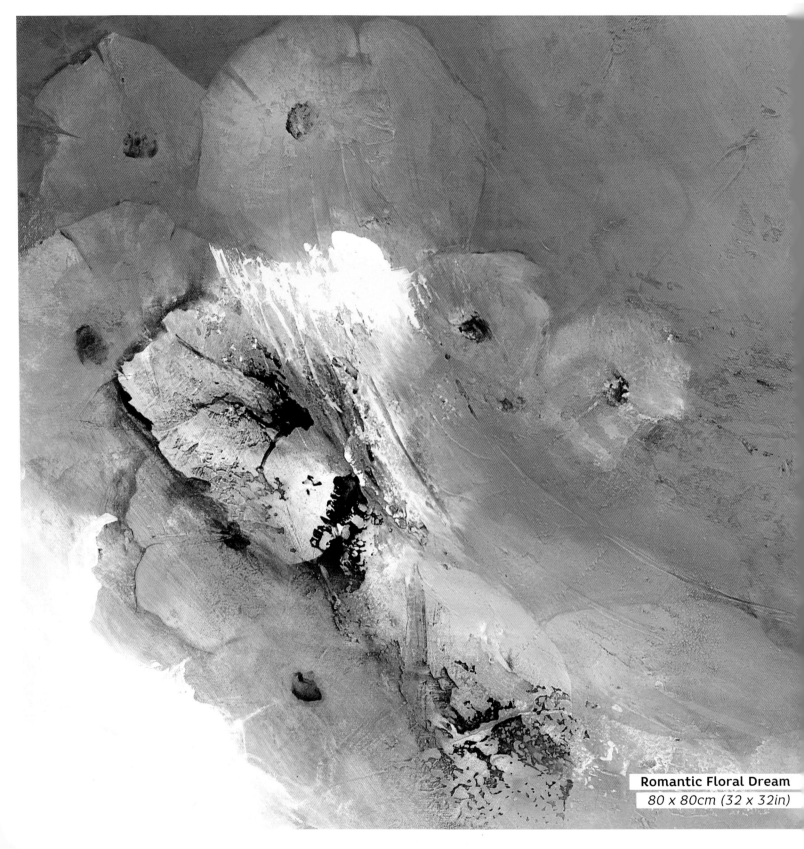

Romantic Floral Dream
80 x 80cm (32 x 32in)

ROMANTIC FLORAL DREAM
PROJECT 15

STEP BY STEP

MATERIALS

Canvas, 80 x 80cm
(32 x 32in)

Acrylic paint –
white, lemon yellow,
permanent orange, black

Airbrush paint – black

Gesso

Brushes/tools –
flat brushes, palette knife

Fine sand

Spray bottle of water

1. Prime the canvas with gesso.

2. Mix together the fine sand and white acrylic paint, and then use this mix to paint a large flower near the centre of your canvas with the palette knife. Paint the background in lemon yellow acrylic paint. Leave to dry.

3. Use a flat brush to paint in the background flowers with white acrylic paint.

4. When these backgound flowers are dry, dab a black spot in the middle of each one. On the flowers created with the palette knife, paint these spots in black airbrush paint.

5. Carefully spray a little water on them so the paint can run into the dips. Highlight the contours of the large flower with black airbrush paint diluted with water.

6. Let a little of the black airbrush mix run over the picture. Leave until completely dry.

7. Dilute the lemon yellow acrylic paint with water and allow this paint to run over a few areas of the flowers. Make sure that some of the petals of the large flower remain white. Leave until completely dry.

8. Dilute the permanent orange with water and use a wide flat brush to paint over two-thirds of the picture, from the top right-hand corner towards the bottom left. Finally, shade the bottom left corner in white.

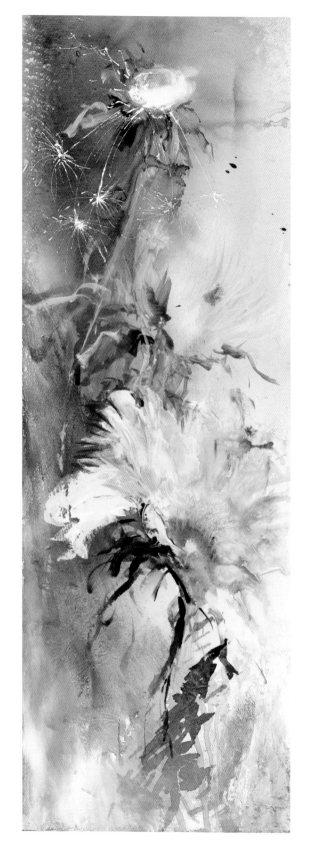

Dandelion
40 x 100cm (16 x 40in)

DANDELION
PROJECT 16

MATERIALS

Canvas, 40 x 100cm
(16 x 40in)

Acrylic paint –
Hooker's green, lemon
yellow, May green, white

Heavy body acrylic paint –
white

Fluid acrylic paint –
lemon yellow,
permanent yellow light,
permanent orange

Airbrush paint –
olive brown, olive green

Gesso

Brushes/tools –
flat brush, angled brush,
palette knife

Coarse sand

1. Prime the canvas with gesso.

2. Dilute Hooker's green with water in one container and lemon yellow in another. Let the green paint flow over the canvas first then the yellow immediately afterwards. Don't let the two paints blend too much, and try to keep an all-yellow area on the right-hand side.

3. With the palette knife, create two flowering dandelions – one larger than the other – and a dandelion clock in heavy body white. Sprinkle a little coarse sand over the centre of the dandelion clock.

4. When dry, paint over the top of the white flowering dandelions with lemon yellow fluid acrylic paint, using an angled brush. Spray with water and let the colour run over the picture. Allow to dry for a few moments.

5. Paint another layer of colour on to the petals of the flowering dandelions with permanent yellow light fluid acrylic paint. Again, spray with water.

Mix together the olive brown and olive green airbrush paints to create a dark shade of green. Using a thin, flat brush, generously paint on the leaves and stalks of the dandelion. Reinforce some of the background in this darker green, concentrating the colour around the top left-hand corner, as this will enhance the effect of the yellow petals.

6. Now add a few lighter accents to the stalks in May green. Dilute white acrylic paint, and let it run around the upper area of the dandelion clock. Spray the paint with water so it can also flow a little further into the picture.

7. Use the angled brush and white acrylic paint to indicate a few little 'umbrellas' on the dandelion clock. Finally, add a few more accents and detail to the large flowering dandelion with permanent orange fluid acrylic paint.

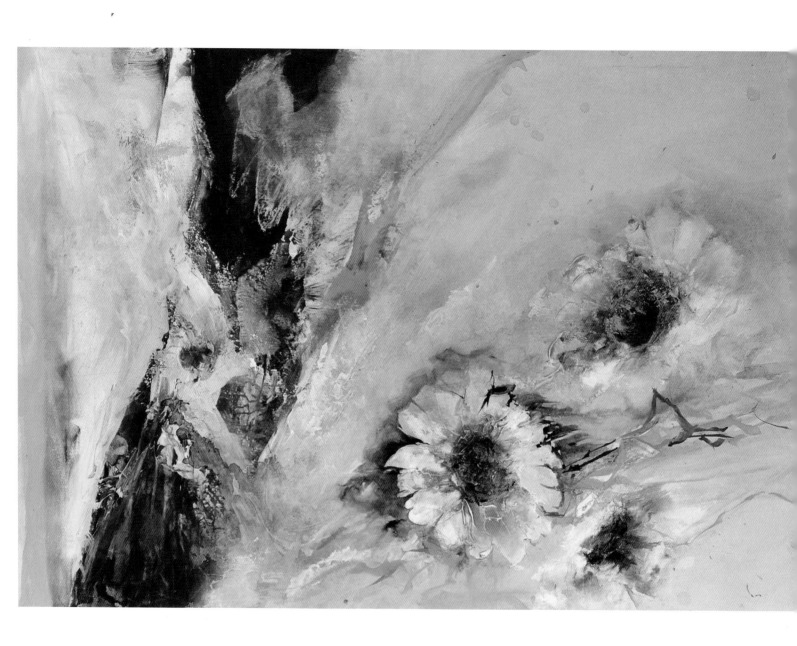

In the Shade of an Old Tree
80 x 100cm (32 x 40in)

IN THE SHADE OF AN OLD TREE
PROJECT 17

STEP BY STEP

MATERIALS

Canvas, 80 x 100cm
(32 x 40in)

Acrylic paint –
lemon yellow, process
yellow, Indian yellow,
Van Dyke brown, black,
light cobalt blue, white

Fluid acrylic paint –
permanent yellow,
permanent orange

Airbrush paint –
Brazil brown

Brushes/tools –
flat brush, angled brush,
palette knives

Fine modelling paste

Sand

Spray bottle of water

1. Paint the whole canvas in lemon yellow acrylic paint. When dry, paint another layer of lemon yellow, adding touches of process yellow acrylic in some areas.

2. Mix a little Van Dyke brown and black acrylic paint with the modelling paste then, using the painting knife, roughly paint a wide tree trunk on to the canvas. Do this while the yellow paint is still wet, so the yellow mixes with the dark brown paint in some places.

3. When dry, apply pure white modelling paste to the picture to create the sunflowers. Sprinkle a little sand in the centres of the sunflowers. Leave to dry.

4. With the permanent yellow fluid acrylic paint and a flat brush, paint the sunflower petals. Spray with water and allow the paint to run slightly over the petals. Leave to dry for a few moments.

5. Add touches of permanent orange fluid acrylic paint here and there on the canvas. Again, spray the picture with water to let the orange run and blend into the other colours a little.

6. Highlight the middle of the sunflower in Brazil brown airbrush paint, using the angled brush. Then, use the brown to paint in shaded areas around the sunflower centres and around some of the petals. Using the flat brush and Brazil brown, paint a few areas on the trunk.

7. Finally, mix together light cobalt blue and a little white acrylic paint, and then paint a narrow stripe of the mix on the left-hand side of the picture. Use this colour to indicate a few sunflower stalks on the picture too.

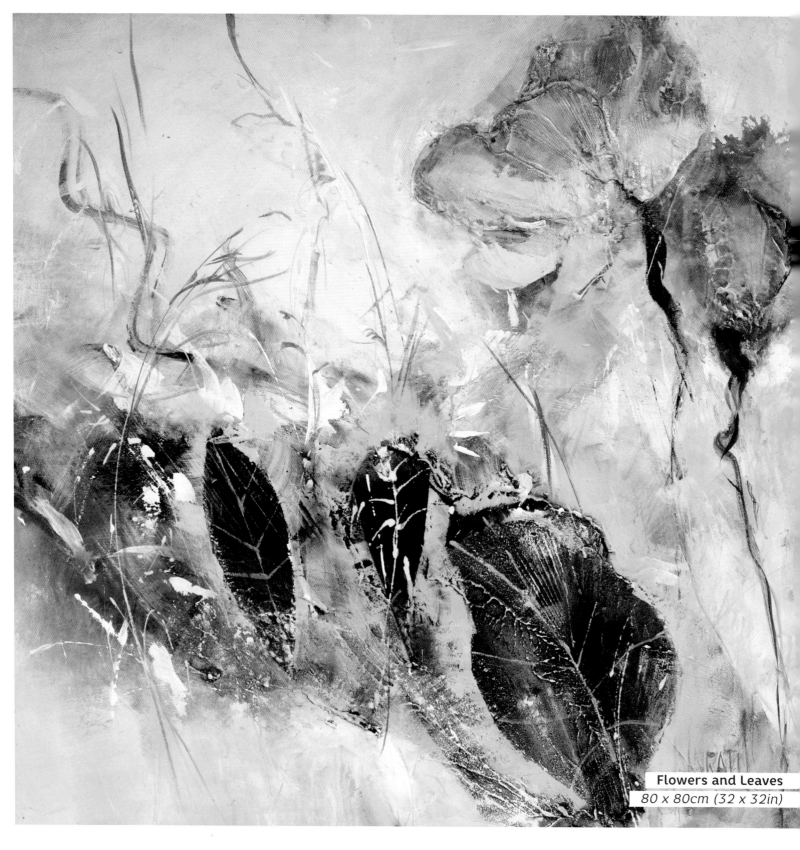

Flowers and Leaves
80 x 80cm (32 x 32in)

FLOWERS AND LEAVES
PROJECT 18

STEP BY STEP

MATERIALS

Canvas, 80 x 80cm
(32 x 32in)

Acrylic paint –
white, lemon yellow,
cadmium orange, black,
pale cobalt blue

Fluid acrylic paint –
transoxide maroon

Brushes/tools –
flat brush, plastic spatula,
palette knife, rigger

Coarse modelling paste

1. Prime the canvas in white acrylic paint.

2. Create large flowers using a plastic spatula and the modelling paste. Switch to the palette knife and draw a broad strip of the modelling paste over the lower half of the picture.

3. When dry, paint in the flowers with lemon yellow acrylic paint. Add a few highlights in cadmium orange.

4. Paint the lower half of the canvas in black acrylic paint. Shade a few areas in this half with transoxide maroon fluid acrylic paint. Leave to dry for a few minutes.

5. Dilute pale cobalt blue acrylic paint with a little water, and use this mix and a flat brush to paint over some of the black and form the leaves. When this is done lightly brush a wash of this colour over the whole picture.

6. With the rigger and alternating between the lemon yellow and pale blue acrylic paints, paint in the veins of the leaves. Use these colours and the rigger to paint a few grasses here and there on the picture.

7. Loosely form the flower stalks in black acrylic paint using a rigger.

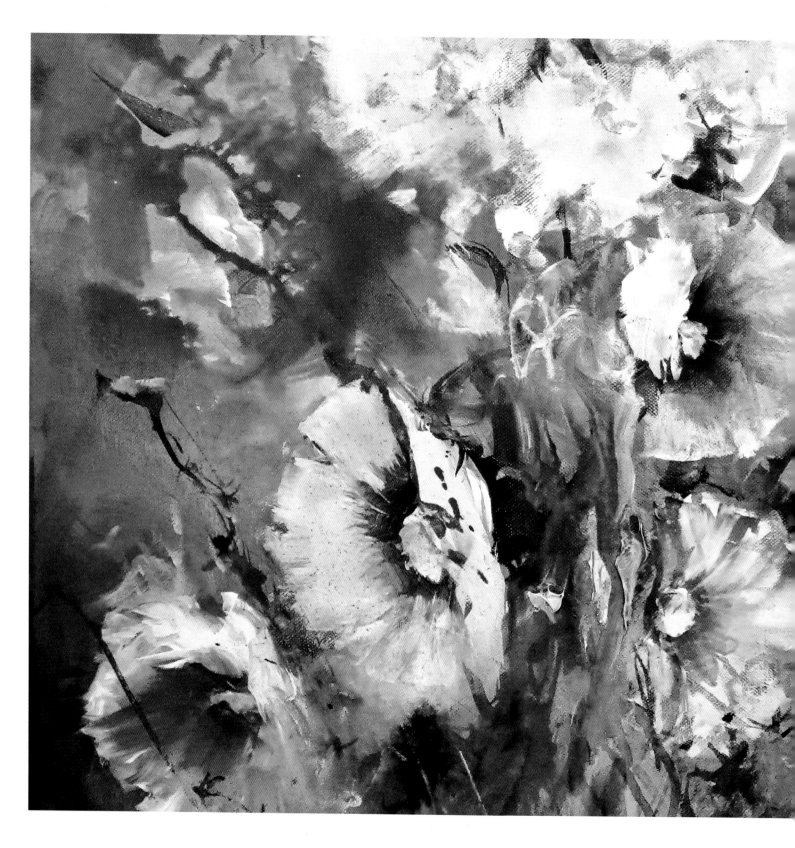

USING MIXED MEDIA

'Mixed media' is collective term that applies to a lot of methods. Here, I'm going to show you how I use this technique in my paintings – I hope it inspires you!

THE TECHNIQUE IN FOCUS
USING MIXED MEDIA

If a picture is produced using more than one technique, then this is called mixed media. The use of different types of paint (watercolours, acrylic paints, airbrush paints) and different materials (sand, paper, plants) also comes into this category. Almost all of my pictures combine a variety of materials, rather than just a combination of different acrylic paints.

Using multiple painting methods at the same time in one picture calls for a certain level of skill. However, don't let this deter you from experimenting, as it can lead you to create exceptional pictures in both design and colour. By trying new methods, you'll not only learn more about the qualities of the different media but also find out which techniques suit your personal style.

TIP

The secret's in the mix! I've combined a variety of materials for these sunflowers: leaves and grasses as templates for shapes and patterning, modelling paste for the three-dimensional petals, and then a combination of acrylic paint spray, fluid acrylics, airbrush paint and acrylic paint to achieve the remaining textures in the painting.

Using these materials together works well for the organic subjects I paint. They reproduce both the soft and coarse facets in nature, just as I perceive them.

Ultimately, the choice of materials is entirely personal. Don't be scared to experiment!

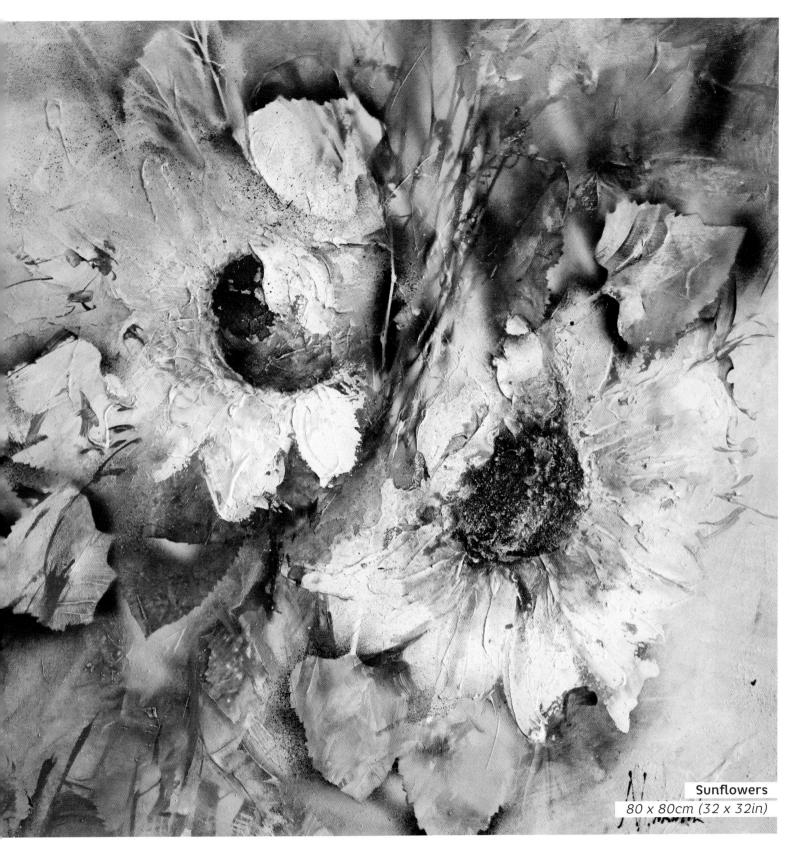

Sunflowers
80 x 80cm (32 x 32in)

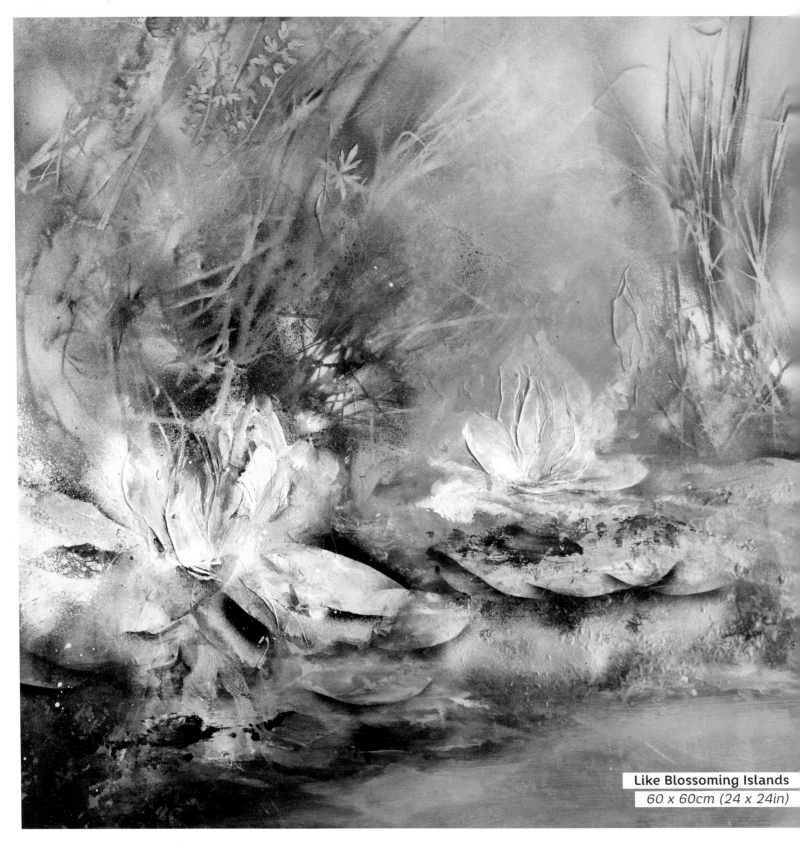

Like Blossoming Islands
60 x 60cm (24 x 24in)

LIKE BLOSSOMING ISLANDS

STEP BY STEP

MATERIALS

Canvas, 60 x 60cm
(24 x 24in)

Acrylic paint –
lemon yellow, process
yellow, Indian yellow,
white, black, cobalt blue,
May green, Hooker's green

Heavy body acrylic paint –
white

Acrylic spray paint –
dark green, pale blue, pale
yellow, white

Brushes/tools –
flat brush, angled brush,
palette knife or spatula

Selection of twigs or coarse
grasses, large round leaf

1. Use the flat brush to apply acrylic paints in lemon yellow, process yellow and then Indian yellow to the left side of the picture.

2. Mix white acrylic paint with a little black and cobalt blue, and apply this mix to the right side of the painting with the flat brush.

3. Paint the areas with the lily leaves in May green and Hooker's green acrylic paint. Leave to dry.

4. Apply heavy body white to the canvas with a palette knife or spatula to form the water lilies. Again, leave to dry.

5. Use the angled brush and lemon yellow acrylic paint to shape the stamens of the water lilies.

6. Now arrange the twigs or coarse grasses over the top half of the picture, having first sprayed them in dark green acrylic spray paint and then here and there in pale yellow and pale blue. Leave them to print on the picture for a few minutes, then remove the twigs or branches.

7. Place a large leaf on the painted green area, under one of the flowers. Spray just the lower edge of the leaf in dark green acrylic spray paint. Carefully move the leaf about 1mm (⅛in), and then spray the lower edge of the leaf in pale blue. Continue in this way several times beneath the flowers until you have as many lily leaves as you desire.

8. If you wish, add a little texture and interest to your picture by spraying some white and pale yellow over the tips of some of the flowers and some dark green in the very background.

9. Finally, using the flat brush and May green and lemon yellow acrylic paints, highlight a few areas of the leaves.

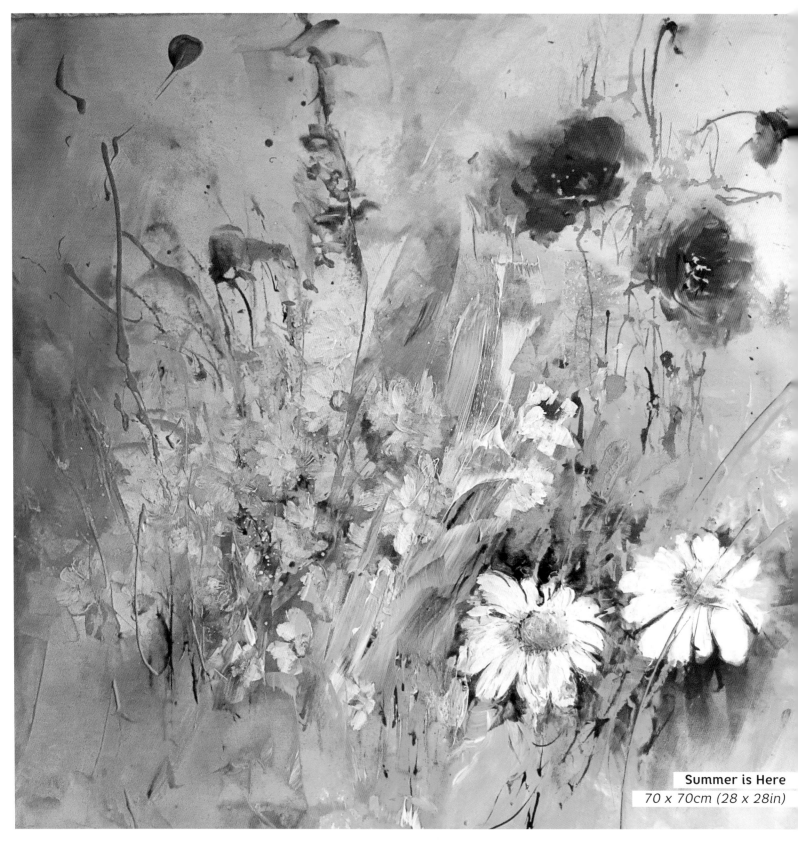

Summer is Here
70 x 70cm (28 x 28in)

SUMMER IS HERE
PROJECT 20

STEP BY STEP

1. Prime the canvas with gesso.

2. Dilute the lemon yellow acrylic paint with water and allow this paint to run over the entire picture. Allow to dry for a few moments.

3. Now dilute the May green acrylic paint with water and, again, allow the paint to flow across the picture. Try to avoid a few of the yellow areas when you do this.

4. When dry, take a thin flat brush and paint poppies in cadmium orange, and then the marguerite daisies in white acrylic paint. Leave until completely dry.

5. Finish the poppies using the angled brush and fluid acrylic paint in permanent red. Using a finger, dab just a drop of transoxide maroon fluid acrylic paint in the centres of the flowers.

6. Emphasize the middles of the marguerites in lemon yellow acrylic paint, adding a drop of Indian yellow over the top.

7. Mix the olive brown and olive green airbrush paints to make a dark green colour and paint this into the background behind the marguerites with the angled brush, to suggest soft flower stalks and grasses in the distance.

8. Using the rigger, paint a few stalks of grass in this dark green. With the same brush, use May green acrylic paint to add in more flower stalks.

9. When dry, use the thin flat brush and acrylic paints in turquoise and white to paint a few lines over the smaller marguerites. This soften their colours a little, so they don't look so stark in the middle of the painting.

MATERIALS

Canvas, 70 x 70cm
(28 x 28in)

Acrylic paint –
lemon yellow, May green, cadmium orange, white, Indian yellow, turquoise

Fluid acrylic paint –
permanent red, transoxide maroon

Airbrush paint –
olive brown, olive green

Gesso

Brushes/tools –
flat brush, angled brush, rigger

Fine sand

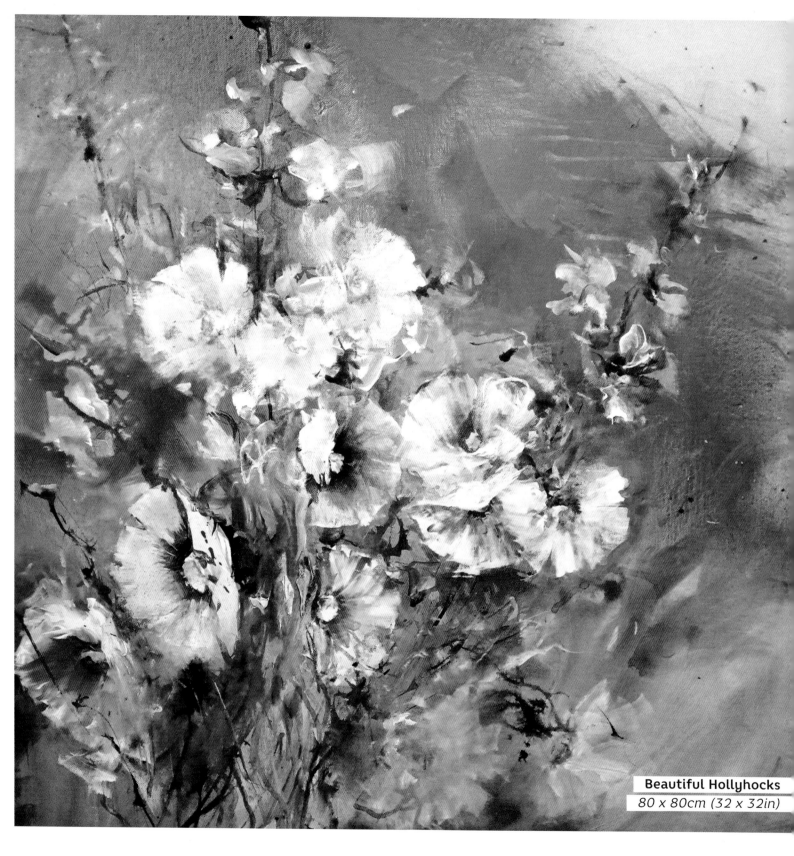

Beautiful Hollyhocks
80 x 80cm (32 x 32in)

BEAUTIFUL HOLLYHOCKS

PROJECT 21

STEP BY STEP

MATERIALS

Canvas, 80 x 80cm
(32 x 32in)

Acrylic paint –
white, grey, magenta,
lemon yellow,
May green, indigo

Heavy body acrylic paint –
white

Fluid acrylic paint –
magenta, transoxide
maroon

Airbrush paint –
olive brown, olive green

Gesso

Brushes/tools –
flat brush, angled brush,
rubber spatula

Spray bottle of water

1. Prime the canvas with gesso.

2. Dilute the grey acrylic paint with water and allow it to run over half the canvas, diagonally.

3. Now dilute the magenta acrylic paint with water and run this over the second half of the picture, diagonally. Leave to dry.

4. With the heavy body white and a rubber spatula, form the shapes of hollyhocks in the centre of your picture. Leave until completely dry.

5. Mix together the magenta and transoxide maroon acrylic paints, and use this mix to paint in the flowers with an angled brush. Spray the picture with water; this will allow the paint to spread and blend the different colours in the flowers, creating different shades of pink.

6. Dot lemon yellow acrylic paint on the middle of some of the flowers.

7. Mix the olive brown and olive green airbrush paints to make a dark green, and use the tip of your flat brush to form the stalks and leaves of the hollyhocks. Use quick, sweeping strokes to achieve the smooth lines in the stems.

8. Add a few highlights to the stalks with May green acrylic paint.

9. Mix the grey and indigo acrylic paints to make a dark blue-grey and paint in the shaded side at the bottom left-hand side of the picture.

10. With an angled brush, finish the flowers by adding a little lemon yellow in the centres, with dots of white over the top.

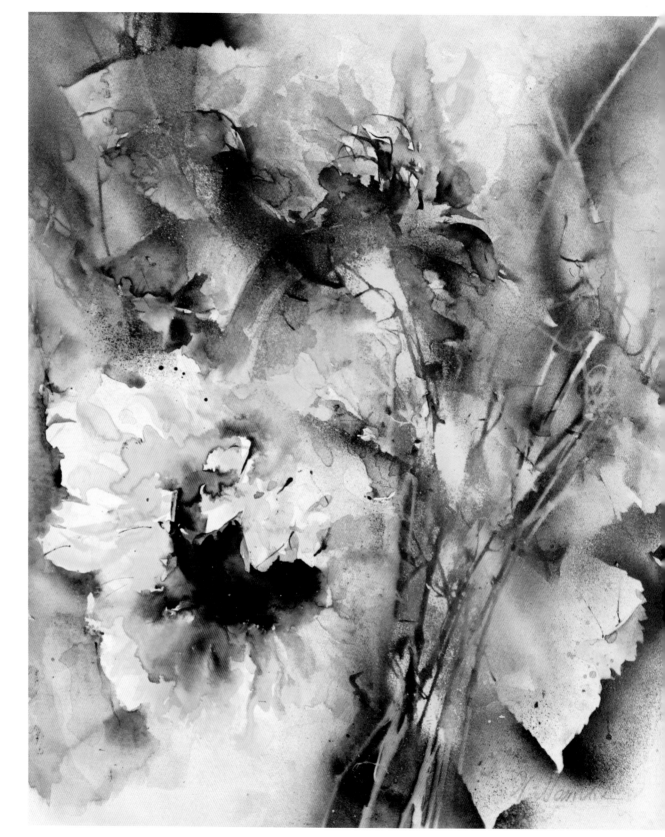

The Colour of Summer
50 x 60cm
(20 x 24in)

THE COLOUR OF SUMMER
PROJECT 22

STEP BY STEP

MATERIALS

Watercolour paper,
600gsm (300lbs),
50 x 60cm
(20 x 24in)

Fluid acrylic paint –
lemon yellow, permanent
yellow, permanent orange,
cobalt blue

Airbrush paint –
Brazil brown, olive brown,
olive green, sepia

Acrylic spray paint –
dark green, dark blue, pale
turquoise, dark yellow

Brushes/tools –
flat brush, angled brush

Selection of leaves and thin
stalks from a sunflower

1. Shape the sunflowers using the angled brush and lemon yellow fluid acrylic paint.

2. Emphasize the middle of the largest sunflower in Brazil brown airbrush paint.

3. When dry, enhance the petals with permanent yellow and permanent orange fluid acrylic paint.

4. For the background, mix cobalt blue airbrush paint with a little water and sweep this over the whole of the picture with a flat brush.

5. Dab in a few green areas using olive brown and olive green airbrush paints. Then, run lemon yellow fluid acrylic paint over the picture, though try to flow this shade mainly where the sunflowers sit.

6. Mix together the olive green and olive brown airbrush paints and, using the angled brush, paint the stalks of the top sunflower.

7. Enhance some of the sections in the middle of the large flower with sepia airbrush paint and the angled brush.

8. Flattening them slightly to ensure their patterns print nicely on the picture, arrange the sunflower leaves on the paper wherever you like. Place a few thinner stalks over the top of them at an angle. Spray the leaves and stalks, carefully avoiding the sunflower petals as much as possible, first in dark green and dark blue acrylic spray paints, then in pale turquoise and dark yellow.

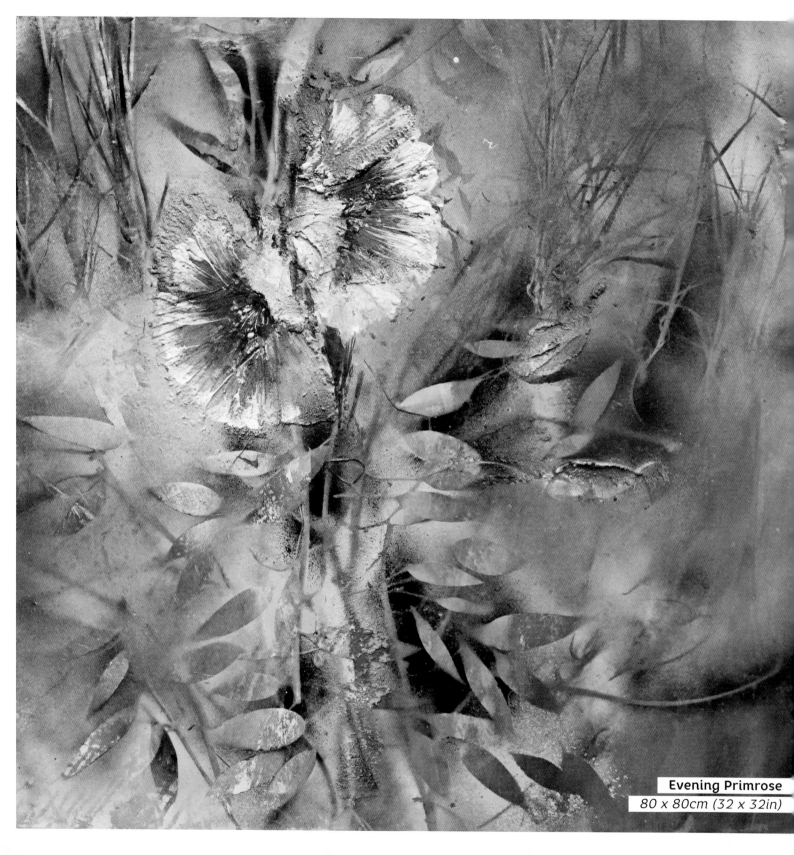

Evening Primrose
80 x 80cm (32 x 32in)

EVENING PRIMROSE
PROJECT 23

STEP BY STEP

MATERIALS

Canvas, 80 x 80cm
(32 x 32in)

Acrylic paint –
lemon yellow, May green,
Hooker's green, grey,
process yellow,
Indian yellow

Fluid acrylic paint –
permanent yellow

Airbrush paint –
Brazil brown

Acrylic spray paint –
dark green, pale yellow,
pale blue

Brushes/tools –
flat brush, palette knife

Selection of
leaves and stalks

Fine sand

1. Paint the left side of the canvas in lemon yellow acrylic paint with a flat brush. Paint the areas where the leaves will later go in May green and Hooker's green. Paint in the remaining right side of the canvas in a pale grey.

2. When dry, use the palette knife and a generous amount of lemon yellow acrylic paint mixed with fine sand to make the two large flowers near the centre of the picture. Suggest two more buds on the right of the blooming flowers. Leave until dry.

3. Now paint the two flowers with the flat brush and process yellow acrylic paint.

4. Mix permanent yellow fluid acrylic paint with a little Brazil brown airbrush paint; this produces a slightly muted brownish-yellow. Use this mix to emphasize the centres of the flowers.

5. Add a few hints of stamens in the middle of the flowers with Indian yellow acrylic paint.

6. Place the leaves and stalks on the picture so that they line up with the flowers, and spray them with dark green acrylic paint. Immediately, spray parts of leaves and stalks in pale yellow and then pale blue acrylic spray paint. Leave for a few minutes so the paint can set, then remove the sprayed materials.

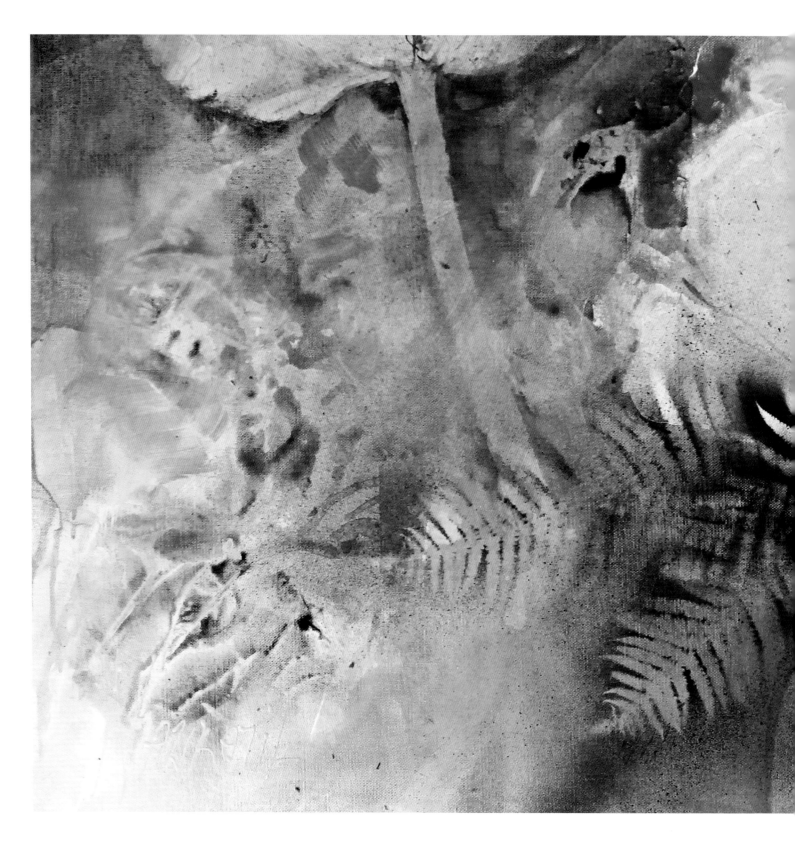

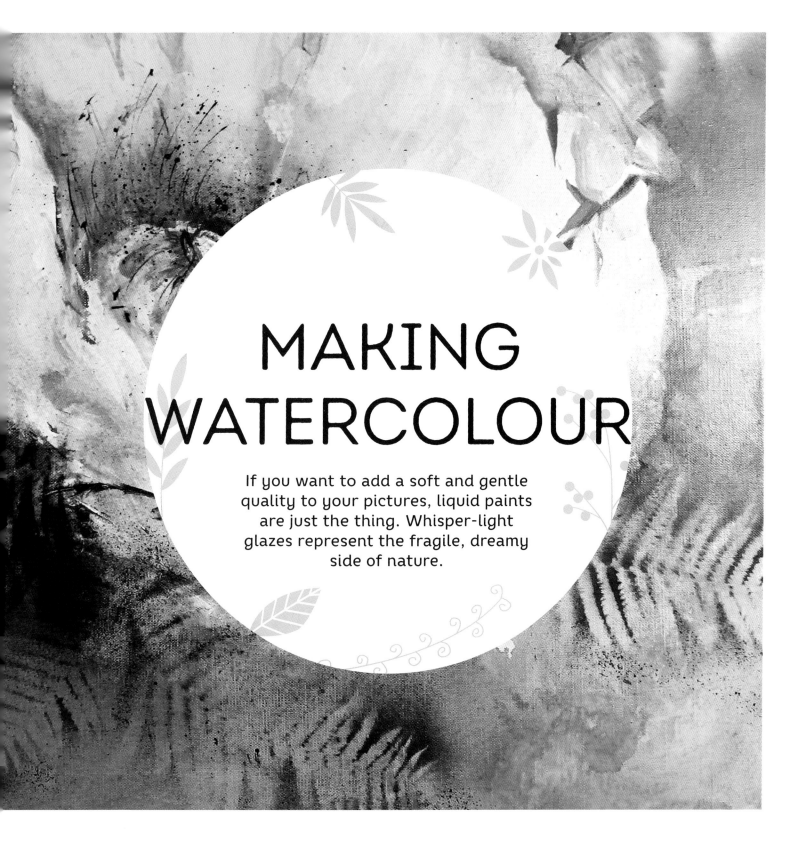

MAKING WATERCOLOUR

If you want to add a soft and gentle quality to your pictures, liquid paints are just the thing. Whisper-light glazes represent the fragile, dreamy side of nature.

THE TECHNIQUE IN FOCUS
MAKING WATERCOLOUR

Liquid paints, lots of water – with this watercolour technique, you'll produce wonderfully light, airy pictures. I suggest priming the base with gesso first, as this will stop the liquid paints from being absorbed by the canvas. If you apply two colours at the same time, they will flow together harmoniously. Allow any new layer of paint or glaze to dry before embarking on the next step. If several colours are layered at the same time, while they are still wet, there is a risk of ending up with a dirty grey shade.

It is often difficult to control watercolour-like paints because the colours often develop randomly. However, this unpredictable aspect is also part of their charm: the liquid paint looks more organic on the canvas, and it also lets the paint naturally form random, effective motifs, lines and splodges within the picture. Essentially, by allowing the paint to 'do its thing', it naturally creates definition.

As you will learn in this chapter, nothing compares with the dynamism, liveliness and fresh-as-a-daisy quality of the watercolour technique.

TIP

Stop trying to control everything in your picture! While at times I like to guide the flow and formation of my paints, I also like to leave as much as I can to chance. I am constantly amazed by how well everything blends together at the end.

Who decides that painted stalks and stems should look 'just like this', and not like something else? Nature herself uses endless arrangements – and even then, they're constantly changing.

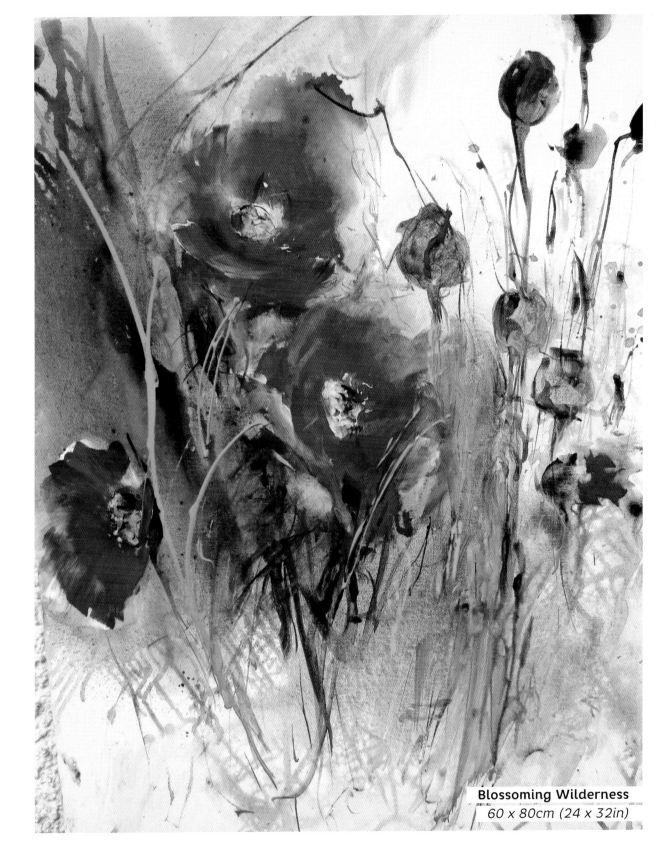

Blossoming Wilderness
60 x 80cm (24 x 32in)

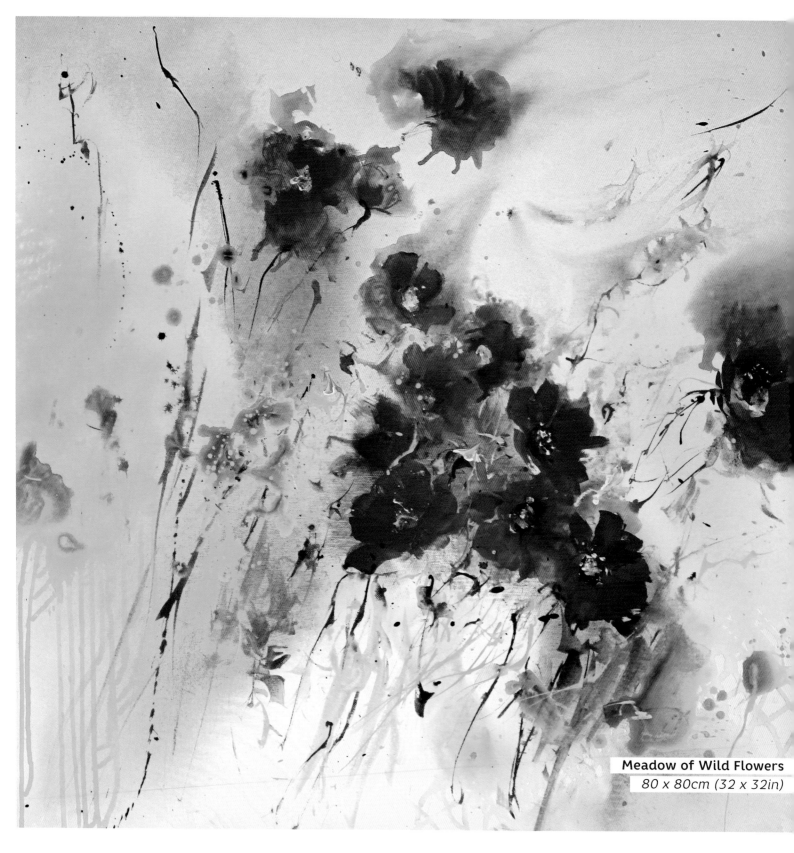

Meadow of Wild Flowers
80 x 80cm (32 x 32in)

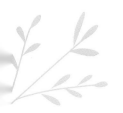

MEADOW OF WILD FLOWERS
PROJECT 24

STEP BY STEP

1. Prime the canvas with gesso.

2. When dry, paint the poppies in cadmium orange.

3. Dilute acrylic paint with a generous amount of water – May green in one small container and lemon yellow in another. Pour the yellow paint diagonally over the middle of the picture. Carefully spray with water, then rotate the picture so that the yellow paint is able to spread. Pour the green paint to the left and right of the flowers, and then spray these areas with water as well. It's fine for the paints to run together, although do make sure that the orange flowers are not covered too much by the green.

4. When dry, if necessary, use a flat brush and cadmium orange once again to shape the poppies. Allow to dry for a few moments.

5. Use the angled brush to finish the poppies with permanent red and transoxide maroon fluid acrylics.

6. Dot a few stamens in the centres of the flowers with lemon yellow acrylic paint.

7. Blend the olive brown and olive green airbrush paints to make a dark green, and then use this mix and the angled brush to paint in a few seed pods within the poppies. With the same mix, and working quickly, paint a few grasses with a sweeping motion over the picture with the rigger, indicating a few leaves here and there. Carefully spray the canvas with a little water, so the airbrush paint is also able to flow nicely over the picture.

8. When dry, emphasize a few more grasses and seed pods in the dark green mix.

MATERIALS

Canvas, 80 x 80cm
(32 x 32in)

Acrylic paint –
cadmium orange,
May green, lemon yellow

Fluid acrylic paint –
permanent red, transoxide
maroon

Airbrush paint –
olive brown, olive green

Gesso

Brushes/tools –
flat brush, angled brush,
rigger

Spray bottle of water

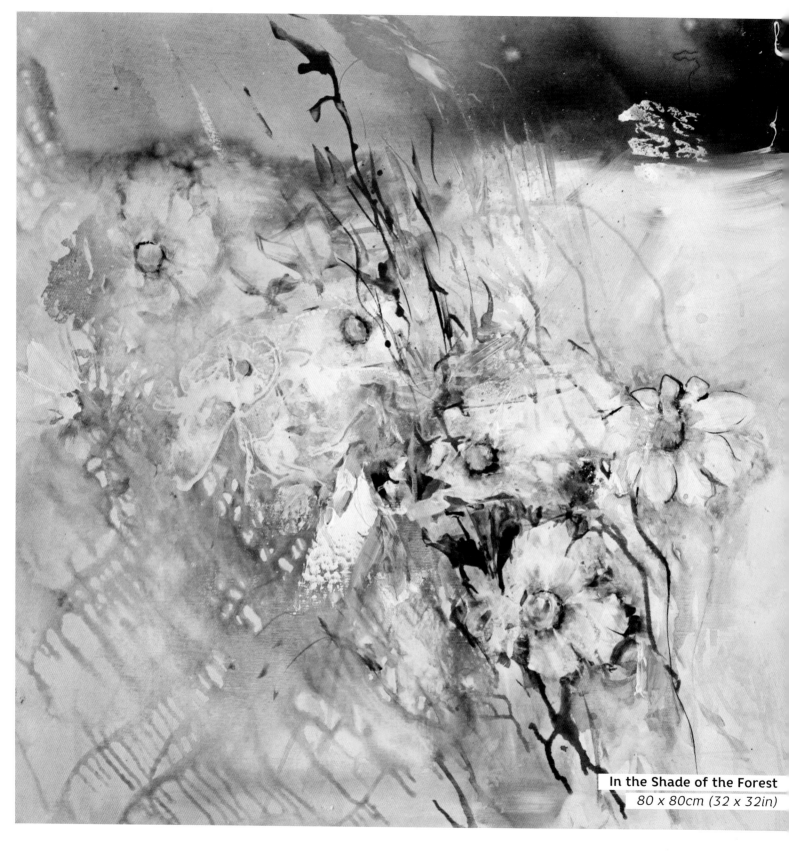

In the Shade of the Forest
80 x 80cm (32 x 32in)

IN THE SHADE OF THE FOREST

PROJECT 25

STEP BY STEP

MATERIALS

Canvas, 80 x 80cm
(32 x 32in)

Acrylic paint –
lemon yellow, white,
Hooker's green, May green

Fluid acrylic paint –
permanent yellow

Airbrush paint –
olive brown, olive green

Gesso

Brushes/tools –
flat brush, angled brush

Spray bottle of water

1. Prime the canvas with gesso.

2. Dilute lemon yellow acrylic paint in a small container with a generous amount of water and allow this to run all over the picture.

3. When dry, dilute Hooker's green in another container with a similar volume of water. Using the flat brush, paint a green area along the top edge of the picture. Indicate a few bushes over the top in undiluted Hooker's green.

4. Using undiluted white acrylic paint and a flat brush, paint the marguerite daisies. Add a lemon yellow dot in the middle of the flowers.

5. When dry, mix together the olive brown and olive green airbrush paints to make a darker green. Using this mix, and with the angled brush, paint the flower stems and shadows around the petals to emphasize their contours.

6. Spray some areas of the dark-green paint with water and rotate the canvas so it can flow over the picture.

7. Add a few strokes of May green to the upper background area to create lighter accents and abstract grasses above the marguerites.

8. Use permanent yellow fluid acrylic paint to indicate a few sunny areas.

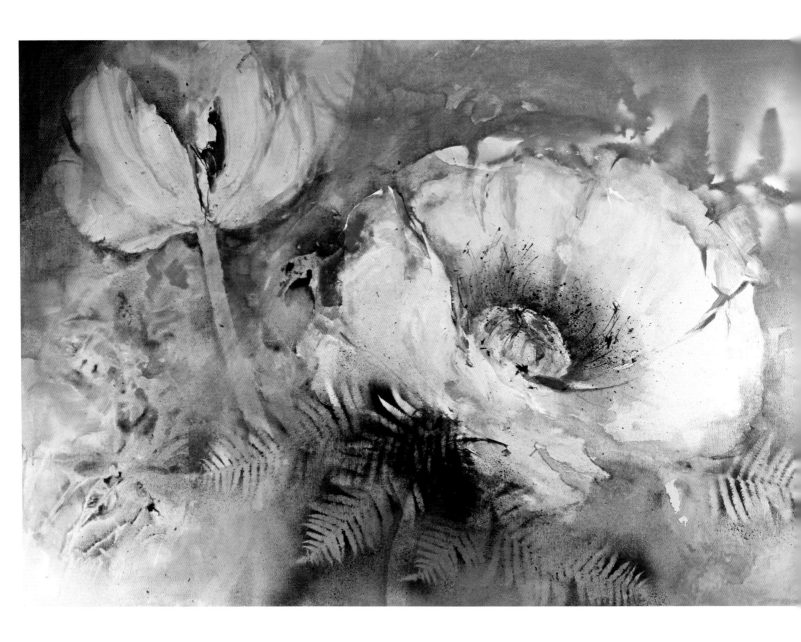

Brilliant White Flowers
70 x 100cm (28 x 40in)

BRILLIANT WHITE FLOWERS

MATERIALS

Canvas, 70 x 100cm
(28 x 40in)

Acrylic paint –
white, black, cobalt blue,
ultramarine blue

Fluid acrylic paint –
transoxide maroon,
magenta, permanent yellow

Airbrush paint –
olive brown, olive green,
orange

Acrylic spray paint –
dark green, white

Gesso

Brushes/tools –
pencil, flat brush,
angled brush, hog hair
brush, rigger

Clear plastic wrap
(cellophane)

Selection of fronded leaves

STEP BY STEP

1. Prime the canvas with gesso. Draw the large flowers roughly in pencil. Use a damp flat brush to lightly shape the middles.

2. Mix a blue-grey shade from white, black and cobalt blue acrylic paints. Thin with water, and allow the mix to run over the whole picture. The flowers should be left white, so blot any unwanted areas with a clean brush dampened with water. Leave until completely dry.

3. Dot airbrush paints in olive brown, olive grey and orange over one another on the left-hand side of the picture. Spray well with water and lay the clear plastic wrap (cellophane) on top. Smooth your hands over the film to blend the colours underneath. This should create leaf-like shapes. Leave to dry briefly, then remove the film.

4. Reinforce the background colour with the blue-grey mix made earlier, using a flat brush. Use the mix once again to shade the edges of the flowers with an angled brush.

5. Mix a little transoxide maroon and magenta fluid acrylic paints, and wash a delicate glaze over the flower on the left-hand side. Shade a little of the colour over the flower on the right.

6. Paint the middle of the largest flower with permanent yellow fluid acrylic paint. Highlight a few areas in the picture with ultramarine blue acrylic paint, adding delicate lines here and there within the largest flower.

7. Thin some black acrylic paint with a generous amount of water, then use the hog hair brush to flick this colour over the middle of the largest flower. Use the same mix and the rigger to create stamen and pod shapes below and in the the centres of the flowers. Leave to dry.

8. Place a few ferns below the largest flower and press down. Spray the fern in dark grey acrylic spray paint. Leave to dry for a few minutes then remove.

9. Finally, place a few leaves over the top part of the picture, and spray them with acrylic spray paint in white. Leave to dry for a few minutes, then remove.

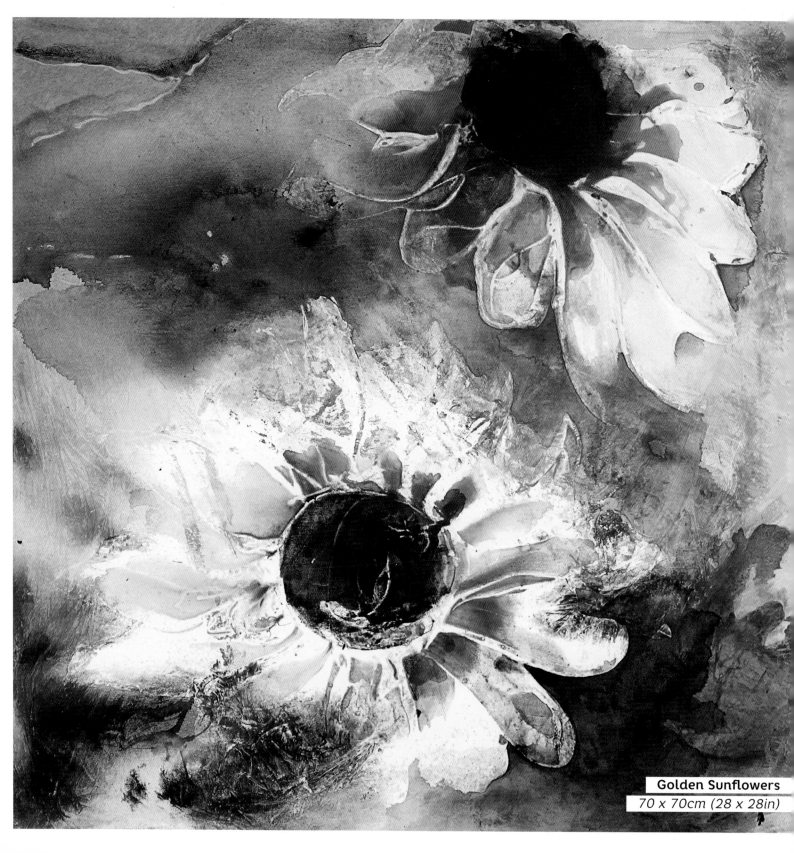

Golden Sunflowers
70 x 70cm (28 x 28in)

GOLDEN SUNFLOWERS
PROJECT 27

STEP BY STEP

MATERIALS

Canvas, 70 x 70cm
(28 x 28in)

Acrylic paint –
white, process yellow

Fluid acrylic paint –
lemon yellow,
permanent yellow

Airbrush paint –
Brazil brown, olive brown,
olive green

Gesso

Brushes/tools –
flat brush, palette knife

Spray bottle of water

1. Prime the canvas with gesso. When dry, dilute process yellow acrylic paint with a generous amount of water and allow this wash to run all over the picture.

2. Using the white acrylic paint and a palette knife, thinly shape the sunflowers and leave until completely dry.

3. Paint the sunflowers with strong lemon yellow fluid acrylic paint, and then spray some water on to the flowers. The colour should run over the edges of the flowers and into the picture. Leave to dry.

4. Add slightly more permanent yellow acrylic paint to the petals of the upper flower, and just a few touches of yellow to the lower one. Spray a little more water over the two flowers to soften the shapes. Leave to dry.

5. Paint the middle of the sunflowers in Brazil brown airbrush paint and then spray these areas with water. Carefully let the brown paint run into the flowers, making sure the colour doesn't flow too much into the flower petals.

6. Mix together the olive brown and olive green airbrush paints to make a darker green. Using a flat brush, paint this shade around the sunflowers to balance the picture and emphasize the outlines of the flowers.

7. Spray some water on to some areas of dark green paint and allow it to run across the picture, turning the canvas as you do so to guide the flow and create abstract leaves.

Blossoming Wilderness
50 x 50cm (20 x 20in)

AFTERWORD

In this book, I have shared with you some of the latest variations on my favourite techniques. I hope this has encouraged you to want to try at least some of the methods that you might have previously thought were too complicated. Put an end to the monotony that you might have slipped into, and let these new, unusual colour contrasts and media into your world! After all – what can go wrong? Pictures painted with acrylic paints in particular are easy enough to correct if you think something has gone wrong, or if you would like to change and improve one or two things.

Why not experiment with new formats too! With rectangular pictures (such as a 30 x 100cm/12 x 40in), watch out for the 'golden ratio' for a more pleasing, proportional painting. Don't feel obliged to stick to portrait or landscape compositions either: a diagonal arrangement of the main motif will increase the dynamism and tension of the picture.

We artists have the prerogative to use our own paintings to adapt our home to the season or to create a particular ambience. If you decorate your home with love, you will enhance the mood and introduce a new energy for yourself and your loved ones!

ABOUT THE AUTHOR

Born and raised in pretty Styria in 1947, the author now lives with her family in in Schönering, Upper Austria. Her home contains a little studio in which she has worked as a freelance artist since 1995.

Waltraud offers art courses in which she combines the technique of watercolour painting with acrylic paints. It is important to her that she encourages her students to vary her iconic motifs and work, step by step, to develop their own individual style.

Her own artistic development began with watercolour painting. Due to the particular intensity of the colours in this technique, she mainly painted flowers. However, other subjects soon followed – motifs that she found on her many walks inspired her. She also enjoyed experimenting with different painting techniques and media. The pictures that you have seen within these pages give you an insight into her complete oeuvre. Besides her several published books, you can also purchase some of her artwork on the artists' platform, International Graphic.

PUBLICATION DETAILS

First published in Great Britain in 2019

Search Press Limited
Wellwood, North Farm Road,
Tunbridge Wells, Kent, TN2 3DR

This translation of *NATÜRLICH ACRYL*, first published in Germany by Edition Michael Fischer GmbH in 2017, is published by arrangement with Silke Bruenink Agency, Munich, Germany.

© Edition Michael Fischer GmbH, Igling, 2017
www.emf-verlag.de

Overall production: Silvia Keller
Product management: Heike Fröhlich
Editor: Petra-Marion Niethammer, Ludwigsburg
All images and original German text © Waltraud Nawratil

English Translation by Burravoe Translation Services

ISBN: 978-1-78221-650-6

SUPPLIERS
If you have difficulty in obtaining any of the materials and equipment mentioned in this book, please visit the Search Press website for details of suppliers: www.searchpress.com

Printed in China through Asia Pacific Offset